→ Retail Graphics

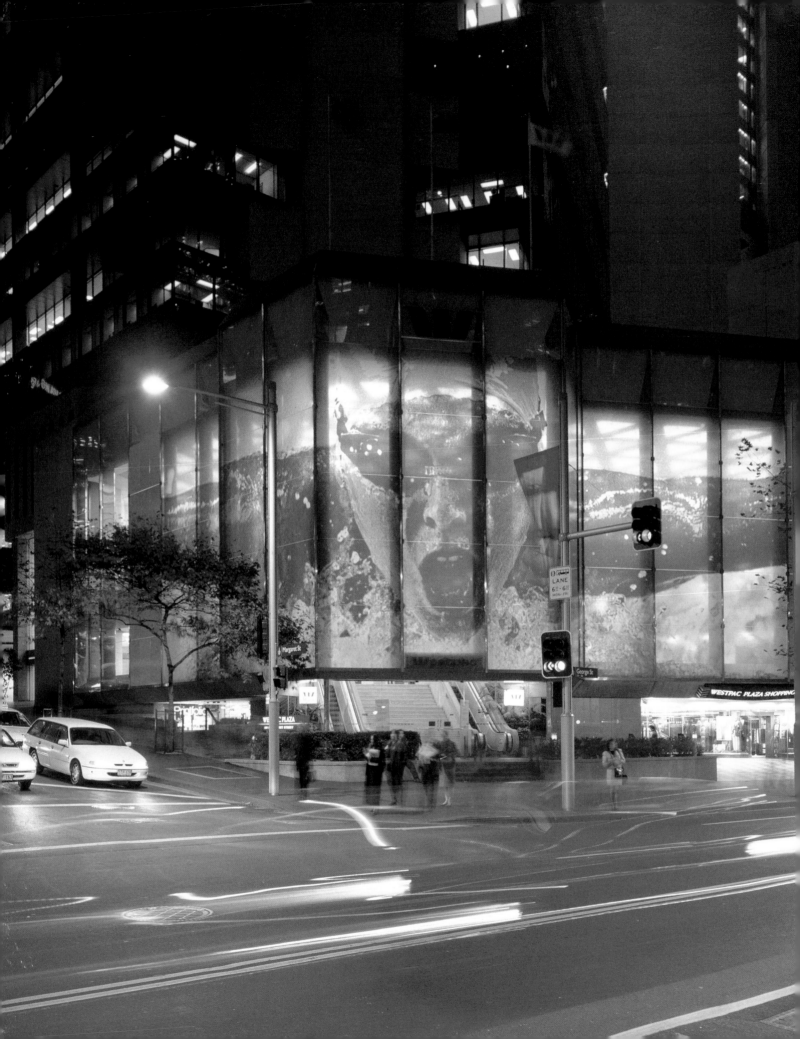

→ Retail Graphics

Giles Calver

RotoVision

A RotoVision Book
Published and Distributed
by RotoVision SA
Rue Du Bugnon 7
1299 Crans-Près-Céligny
Switzerland

RotoVision SA
Sales and Production Office
Sheridan House
112–116a Western Road
Hove, East Sussex, BN3 1DD, UK
Telephone: +44 (0)1273 72 72 68
Facsimile: +44 (0)1273 72 72 69
E-mail: sales@rotovision.com
Website: www.rotovision.com

10 9 8 7 6 5 4 3 2 1

ISBN 2-88046-621-0

Book designed by Lippa Pearce

Production and separations by
ProVision Pte. Ltd. in Singapore
Telephone: +65 334 7720
Facsimile: +65 334 7721

Every decade brings new advances in lifestyle, work, transport, communications, entertainment and leisure. The 'shock of the new', to borrow a phrase from Robert Hughes, co-exists with the comfort of the existing to form a new dynamic. The new then becomes the commonplace and is in turn replaced with a new impetus...and so it goes on.

One world which reflects this well is the retail world,
where practices that have been commonplace since time
immemorial are constantly being joined by new forms of retailing.
E-shopping which has only emerged in the last decade, is the first
of these new forms that springs to mind but there are others
such as 'experiential retailing', as epitomised by Niketown.

Modern retailers operate in a world of complexity and fluidity,
where they face new choices and challenges all the time:

→ **Self-service versus serviced**
We live in a self-service world but still bemoan the fact that no-one provides good
service. Indeed, when we do experience it, for instance in a store like Waitrose
in the UK where they insist the shop floor staff take you to the product you are
looking for, we reward the retailer with our loyalty.

Retailers constantly wrestle with the issue of service in relation to staffing levels
and profit margins, and they are constantly looking at ways of satisfying consumers
through other avenues such as displays and literature.

→ **Niche operator servicing the individual or multi-product operator**
servicing the household
On the face of it these two seem mutually exclusive but with retailers
developing the notion of 'retailing through one pair of eyes' niche operators
face the challenge of meeting and exceeding customers' expectations if they
are to combat the convenience shop aspect of the multi-product retailer.

→ **Old niche operator or new niche entrepreneur**
It started with coffee bars and tie and hosiery specialists but now it seems like
every week a new niche operator appears: noodle bars, wrap bars, fast-food
soup outlets, candle shops and nail salons. For the new operator, the challenge
is to communicate their offer and differentiate themselves in the marketplace.
For the old niche player, the challenge is to see off these new upstarts in their
territory, such as the lunchtime takeaway market, and retain their customers.

→ **High street player, out of town supercentre or stadium category killer**
Globalisation has come to the retail world in a big way. Historically, many retailers
have found that their offer hasn't always travelled well. More recently, though, the
big US giant Walmart has stirred things up with forays into Germany and the UK.
It brings with it sophisticated retailing techniques and sheer physical size.
Incumbent retailers look to their laurels if they are to fight off these new entrants
like Walmart, where the convenience shop is taken to new levels.

➔ Value or luxury positioning

These two are poles apart but they still face the same challenges of communicating their core positioning, attracting customers and providing them with an enjoyable shopping experience.

➔ Loyalty programme or price-promise operator...or both

Once it was enough to lay your wares out and let customers choose. With increased competition customers need enticing and they need to be reminded why they should choose one retailer over another. The 'promiscuous shopper' is a reality now more than ever before simply because of the sheer choice they have. In the UK most towns have at least three supermarket chains offering range, value and convenience and coffee bars seemingly spring up like mushrooms overnight.

In a bid to counter this promiscuity and achieve the Holy Grail of all stores (namely, to become a destination shop) retailers have responded with loyalty card programmes. Some, like The Boots Company in the UK have developed sophisticated in-store kiosks which reward shoppers with tailored offers when they visit the store and swipe their Advantage card through the machine.

➔ Market innovator or market follower

Increased competition is leading to market innovation in many sectors. The most dramatic of these innovations is experiential retailing where the twin worlds of leisure and retailing meet, coalesce and form a powerful new offer. In many ways these new formats break many of the tenets of retailing; for example, they sacrifice sales per square foot in exchange for building a brand experience. Yet they do this because their primary objective is to build brand loyalty.

On the high street this has found expression in the same mix of leisure and shopping but on a less grand scale. In the book world many shops have linked up with coffee bar chains and fashion outlets and even banks and building societies are now joining them.

If the dynamics in the retail world were not enough the last decade has also seen major developments in retailers' analysis of customer behaviour. Previously developed thinking about customers' journeys through a store (the process of enter, browse, be inspired/involved, learn, consult, purchase/pay, learn and re-visit) is now being joined by strategies to address different types of shoppers and different modes of shopping.

Much of this 'modal thinking' is based on the knowledge that for many modern consumers 'value for time' (to use the Henley Centre's term) is just as important as value for money. Many consumers are simply too strapped for time. Their work and leisure time is filled to the brim with activities and commitments and this affects the way they shop.

As a consequence, a customer may simply want to find their purchase quickly, pay and exit. At other times they may want to shop more leisurely and will therefore take more time to select, appraise and purchase. One factor, which complicates all of this, is that customers change mode depending on time of day and day of the week.

Against this overall background retailers have four key weapons in their fight to survive and win in the retail world: brand power, logistical strength, customer service and store environment. This book is concerned with the latter two and how retailers employ graphics to communicate their offer and differentiate themselves from the competition.

Retailers provide customer service through human interaction, using their shop-floor staff, helpline and customer-service departments and delivery teams. They also provide it through the in-store information they impart – from providing directions, signing departments, dispensing facts, explaining product benefits and communicating offers. These graphic interfaces are the stuff of this book.

Store environments are a compound of architecture, interior design and layout, fixtures and fittings, and product merchandising and displays. Graphics play a major role in contributing to many of these areas both on a permanent level – for example, store plans – and refreshment level, where environments change to accommodate seasonal offers, new product lines and brand promotions – not to mention consumers' expectations of something new each time they visit.

The graphic media which are employed to great effect by retailers and their designers comprise window displays, store plans and maps, directional signs, department beacons, banners and posters, merchandising displays, floor and wall graphics, and 'take home' elements like carrier bags. Often they feature on the outside of stores as well as inside.

Each one in turn is utilised to engage and inspire customers, to convert interest into purchase, to communicate an experience or experiences, to reinforce a retailer's or brand's values and personality, and to direct customers quickly and efficiently around the store.

The wonderful feature of the graphic elements employed to address service and environment is the sheer variety of approaches employed and the tremendous inventiveness exploited to keep on stimulating customers the world over. This book attempts to do them justice.

02 EXTERIOR GRAPHICS

Graphics are applied to retail exteriors in a number of ways and are used to achieve a number of different things.

Applications range from painted finishes on buildings and new build/refurbishment hoardings to large-scale colour outputs applied as seasonal or permanent poster sites; from signage systems in all their manifestations to banners and flags; from window displays and window treatments like frosting or decals to back-projected images or lighting effects on to screen or windows; and from impermanent media to graphics applied as architectural features.

Uses range from simple retailer identification to product and seasonal-offer communication; from customer enticement and inspiration to brand establishment and differentiation, from changed offer or proposition communication to retailer profile raising.

Operating within planning approval, cost and safety constraints, retailers and designers are producing a huge variety of graphic treatments. Using 'traditional' methods, (such as applied paint) and new technologies (such as digital image manipulation and projection) the retail world is alive with invention and innovation.

This innovation and invention is widespread, from retail parks to shopping malls, from the high street to local store. As many of the illustrations that follow demonstrate, designers working in this field often think 'outside of the box' in a literal sense and produce graphic effects which complement and sometimes transcend the built environment.

Retailer Identification – Dymocks [1]
This dramatic signage for the bookshop Dymocks in Australia exploits the architecture of the site to great effect. The powerful signage blade at the corner of the store is a striking beacon on the street, locating the store and projecting the retailer's brand. The sign itself is made up of the Dymock's logo overlaid on to a 'form language' composition based on titles and quotations from classic books. This form language was also applied to the glazing in varying degrees of intensity to help obscure shelving in the second-level windows and the concrete structure visible through the glazed facade.

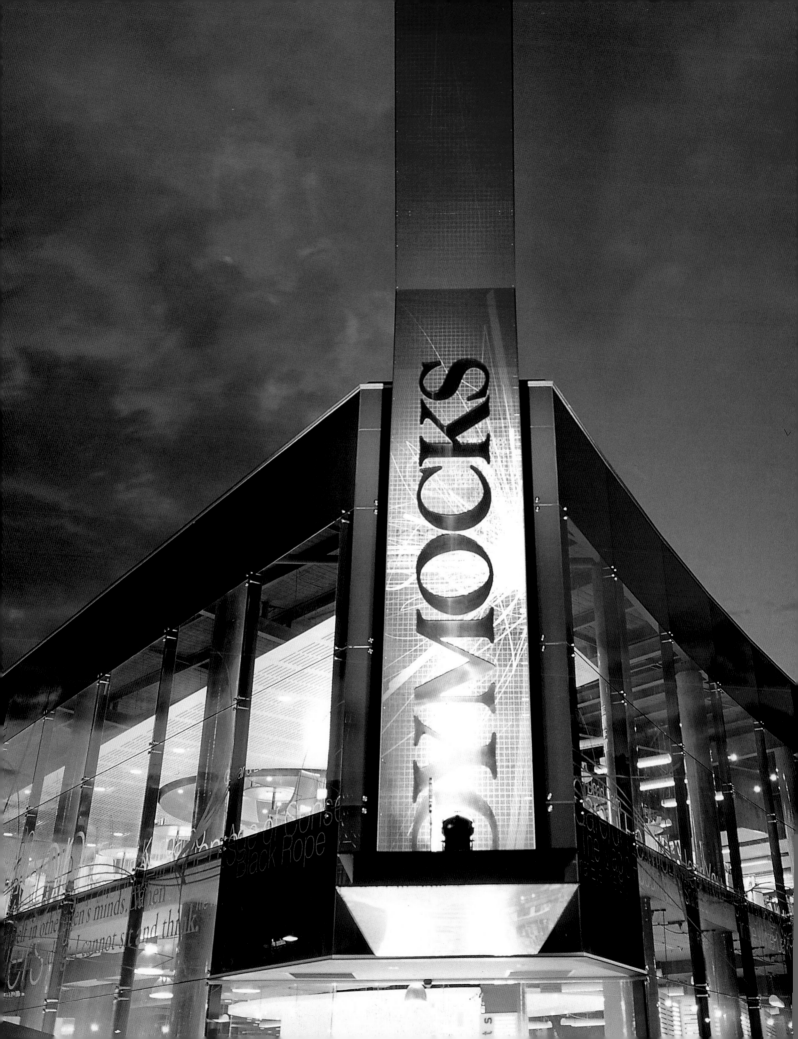

Client Next
Design Din Associates
Location London, UK
Date 1995

Client Levi's®
Design Checkland Kindleysides
Location San Francisco, USA
Date 1999

12

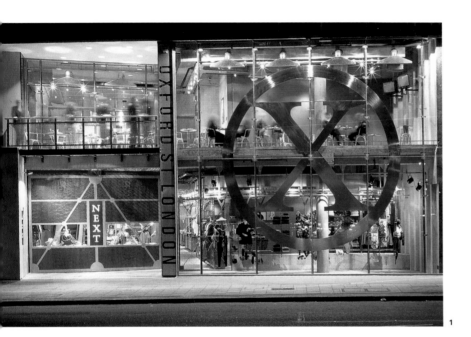

1

Brand Projection – Next [1] and Levi's® [2]
The strength of these two graphic treatments
lies in their size and simplicity, and their
recognition of the way consumers' minds work.
By keeping the graphics simple and using scale
to dramatic effect they achieve more impact.
By using shapes and colours which have assumed
a significance over time as brand identifiers they
exploit the consumer's ability to focus on the
familiar or preferred. People recognise brands
that occupy a share of their mind. Because of
their emblematic quality they even filter them
out from all the visual and verbal clutter around.

2

Client Nike Europe
Design Tango
Location London, UK
Date 2000

Window Displays – Nike [1/2]

Nike has become almost synonymous with the notion of the retail brand experience so there is a big expectation that its use of exterior graphics will 'push the envelope'. As these examples illustrate, Nike is a sophisticated mixer of different media: product, graphic panels, window decals and dynamic mannequins. The simplest of its devices, the circular window roundels, act as magnets drawing in passing consumers just as powerfully as the larger graphics. The roundels are actually magnifying glasses which help make a window statement out of a small product.

1

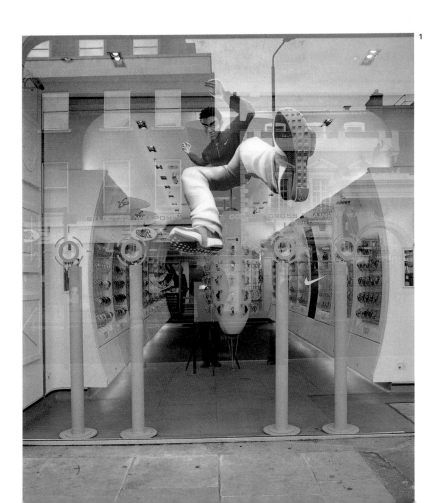

2

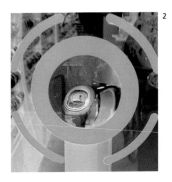

14

Window Displays – Accessorize [1/2]

The subject of window displays could fill a book itself; indeed there are one or two very good books available, so it may seem perverse to cover the subject with only a few examples, but they use graphics so well rather than relying on products or mannequins.

To my mind Accessorize's window graphics are so strong because they employ simplicity, ideas and glamorous fashion associations to make a hero of their products. They do this in a way that is recognisably theirs so that consumers begin to recognise their house style as part and parcel of their retail personality. And to cap it all it's done with humour and aplomb.

The simplicity of the hanging banners has another benefit. It allows Accessorize to cater to their different window formats across their 130-plus stores and enables the store staff to implement the campaigns consistently and easily.

EDITOR'S CHOICE:
Sequinned disco bag 19.99

EDITOR'S CHOICE:
BEAD AND BRAID BAG WITH POMPOMS £24.99

EDITOR'S CHOICE:
Zigzag sequinned bag 24.99

Client Accessorize
Design Martin Jacobs Design
Location UK-wide
Date 2000

→

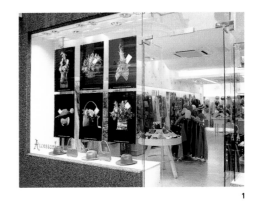

1

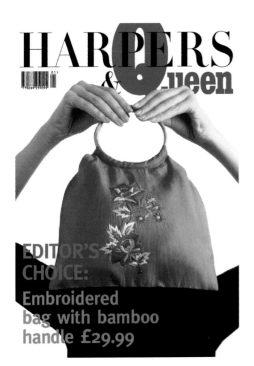

HARPERS & Queen

EDITOR'S CHOICE:
Embroidered
bag with bamboo
handle £29.99

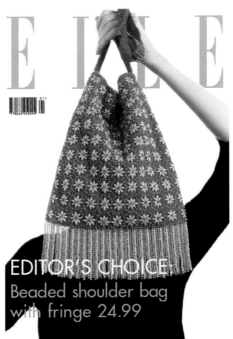

ELLE

EDITOR'S CHOICE:
Beaded shoulder bag
with fringe 24.99

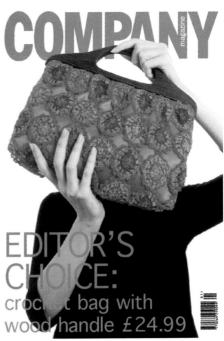

COMPANY magazine

EDITOR'S
CHOICE:
crochet bag with
wood handle £24.99

2

Retail Graphics
Exterior Graphics

Client Warner Brothers
Design The Partners
Location New York, USA
Date 1996

16

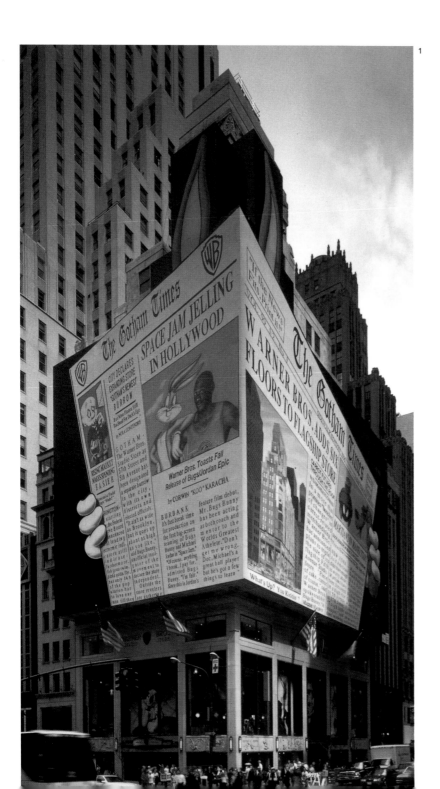

1

Hoardings – Warner Brothers [1]

The development of new large-format printing technologies has given a new lease of life to the design of construction hoardings for new store builds or refurbishment programmes. Yet this wonderful project by The Partners for Warner Brothers was hand-painted by the Studio Scenic Art Department in Hollywood. Sitting on the corner of 5th Avenue and 57th Street, Warner Brothers' flagship store underwent massive refurbishment in 1996. To tell shoppers the store was still operational, and thus avoid loss of revenue, was left to Bugs Bunny and the Gotham Times, featuring masthead letters more than eight feet high!

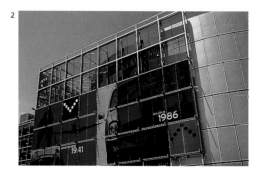

2

Client Fox Studios Australia
Design Emery Vincent
Location Sydney, Australia
Date 2000

Client Selfridges
Artist Sam Taylor Wood
Location London, UK
Date 1999

→

Hoardings – Fox Studios [2/3/4/5]

The retail development at Fox Studios, Australia, comprises four buildings, each designed by a different architect, each reflecting a different style. Also incorporated into the development is a working film studio which attracts international film-makers, artists and actors. Emery Vincent's brief was to develop a graphic overlay which would help unify and promote the precinct. Leveraging the appeal of the film studio they developed a series of bright red/orange images which reflect the history of Australian film-making. These were then integrated into the fabric of each of the buildings, using different surface finishes and materials from perforated metal to plastic and glass. Because of their size and visual richness the hoardings are dramatic and eye-catching during the day and perhaps even more so at night when they are illuminated.

Hoardings – Selfridges [→]

In June 1999 Selfridges committed to undertake the external refurbishment of its Oxford Street site. This refurbishment involved cleaning the exterior of the building with specialist equipment and required the entire facade to be covered in scaffolding. As the refurbishment period was estimated to take approximately six months Selfridges decided to turn the scaffolding, a potential eyesore, into a spectacular art space, in fact the largest photographic piece of art (900 x 60 feet) to ever adorn a structure, which would not only appeal to customers but would also attract visitors to Oxford Street.

'XV Seconds' by Sam Taylor Wood, took four weeks to install and was in position for five months. The artwork was created using 56,000 square metres of print and was installed using over 1,300 metres of rope and 6,000 eyelets. 'XV Seconds' created an excitement around, and interest in, the Selfridges brand that far exceeded what could be achieved with conventional media. It also demonstrates how retail boundaries can be pushed to drive brand perception.

3

4

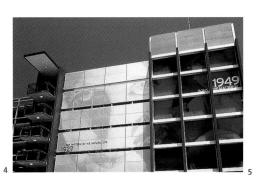

5

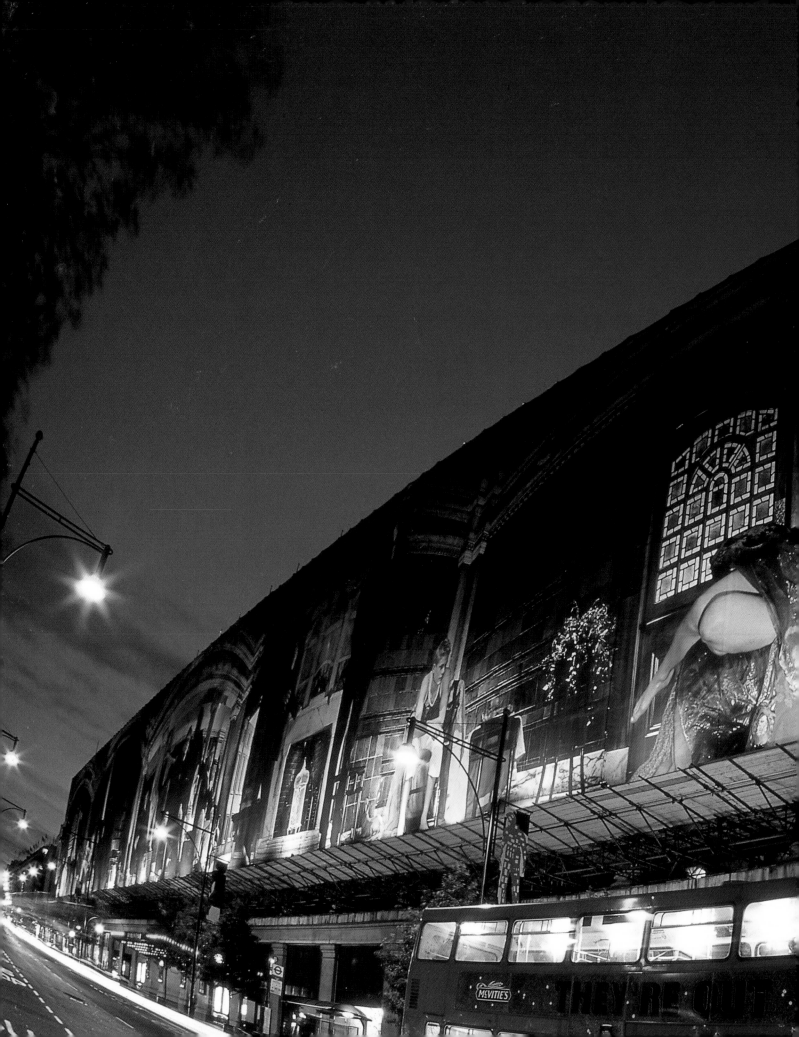

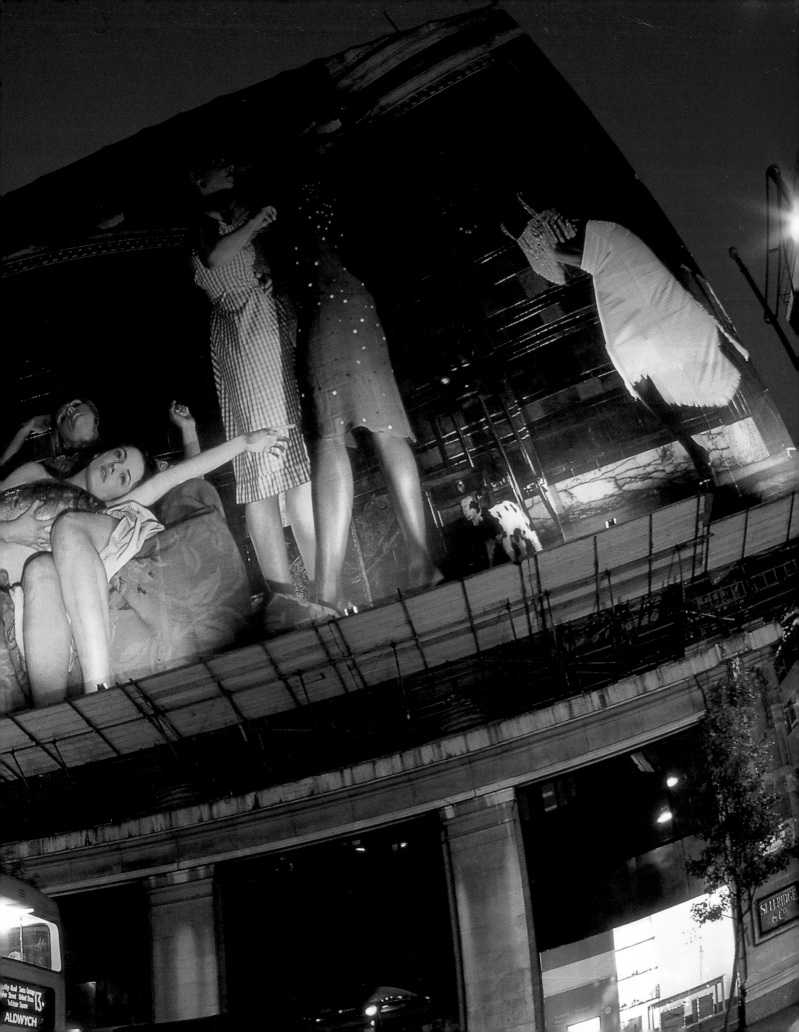

Client Whittard of Chelsea
Design Carte Blanche
Location London, UK
Date 1999

Client ATT
Design Din Associates
Location Taipei, Taiwan
Date 1993

20

1

2

3

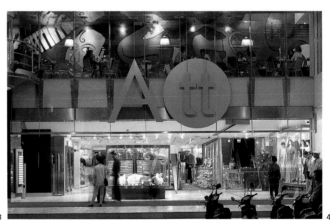

4

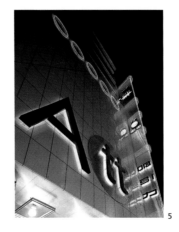

5

Client Lakeland Limited
Design Lumsden Design Partnership
Location Cambridge, UK
Date 2000

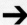
Window Treatments – t-bar [1/2]

The application of branding to the windows of these tea and coffee bars is sympathetic to the whole design of the bars whilst providing them with a strong identity. Applied to the windows at this scale they are prominent and draw the eye but also allow customers to see inside and be enticed by the whole interior mood. Inside the neutral backdrop of an off-white shell allows the selective use of graphics to have more impact. Indeed, the graphics in this project are a testament to the saying 'less is more'.

Murals – ATT [3/4/5]

ATT exploits its glass facade as an attention-grabbing device to lure and seduce shoppers into the store. It does this by making graphics viewed from the exterior an intrinsic part of the interior. Here the mural has the effect of drawing one's eye and the eye thus drawn focuses on the shoppers enjoying the department store's bar. The clearly pleasurable experience of the store acts as an additional draw to shoppers walking by.

Blinds – Lakeland [6]

Not all exterior graphics have to be on a large scale. Lakeland's simple use of their first-floor windows is an imaginative exploitation of a space many retailers ignore. Backlit, these blinds simply but effectively communicate the retailer's branding, and do it without recourse to a huge budget.

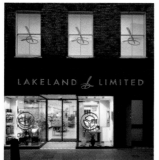

6

Client B&Q
Design SCG
Location Warrington, UK
Date 2000

22

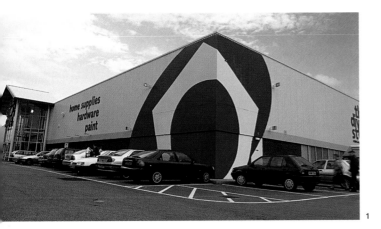

1

Applied Graphics – The DIY Store [1] and Halfords [2]

SCG's work for B&Q on their new supercentre concept store illustrates how the whole exterior can be utilised to make a statement. The scale of the graphics attracts the attention of passers-by, and given that the store is on a retail park the likelihood is that passers-by will be in cars so the graphics need to work hard. In this case the bright colour palette and arresting use of the store's logotype on the corner of the building turn the whole exterior of the building into an attention-grabbing focal point.

Similarly, Halfords has used the exterior of their stores to tell consumers that they are offering something quite different to their normal bill of fare. Consumers familiar with their old store colour palette of grey and blue cannot help but be intrigued by the dynamic and vibrant use of colour on this new store. Combining bold colours and strong graphic devices, like the chevrons and arrows, the store is an overt signal to consumers that they should explore inside. The success of this approach has been borne out by sales. Where stores benefited from both a new exterior treatment as well as an in-store refurbishment Halfords witnessed sales increases of over 30 per cent in comparison to stores where store changes had been restricted to an interior refurbishment only.

Client	Halfords Limited
Design	Lippa Pearce &
	Ben Kelly Design
Location	Swansea, UK
Date	1999

→

23

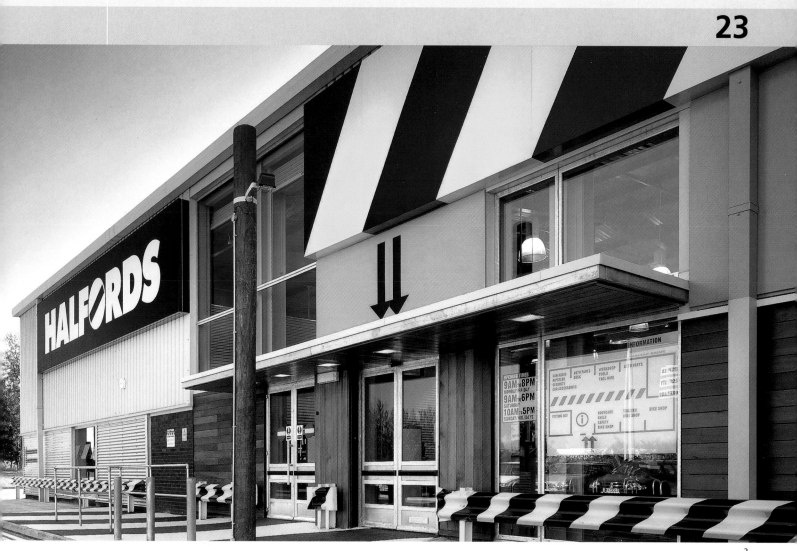

Client Eli's
Design Chemayeff & Geismar
Location New York, USA
Date 2000

Client American Natural
 History Museum
Design Pentagram
Location New York, USA
Date 1995

24

Banners – Eli's [1/2] and the
American Natural History Museum [3]

Having been transfixed by Akira Kurosawa's use of multicoloured banners strapped to the backs of soldiers in films like 'Throne of Blood' and 'Kagemusha', banners have always seemed to me a particularly powerful method of communication. Their impermanence makes them highly flexible and easily changeable while their material construction often adds movement and fluidity to the format – catching one's attention as they flap and ripple in the wind. Hung like Eli's, namely at right angles to the store, they have the additional benefit of signalling a store's presence to shoppers walking on the same side of the road as the store. With an eye to total branding, Eli's strong use of bright colours and the repetition of their store name finds an echo in their carrier bags. One can imagine the effect in Manhattan as shoppers see the bags and then see the banners and make the link – doubly comforting if you are a destination store and your bags have cachet.

In contrast the American Natural History Museum's (okay not strictly retail but there is nothing stopping retailers doing the same) use of banners gains its wonderful effect from the parts combining to make a dramatic whole. Here the cumulative scale does true justice to the subject of dinosaurs, and the mightiest of the dinosaurs, Tyrannosaurus Rex.

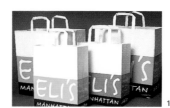

1

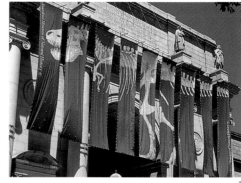

2

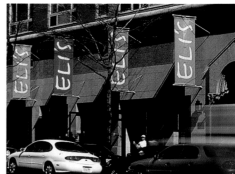

3

Client Ray-Ban®	**Client** Roy Rivett
Design Checkland Kindleysides	**Design** Spacecraft
Location Atlanta, USA	**Location** Bluewater, Kent, UK
Date 1996	**Date** 1999

Structural Graphics – Ray-Ban® [4]

Quite apart from loving the whole ambience of this store the door handles are quite inspirational. This simple device, 'structural' but graphic in its simplicity, does so much to communicate what the brand is all about and brings a smile to your face even before you enter the store. What could be better than to have customers enter in the right emotional frame of mind to enjoy their visit?

Structural Graphics – Into the Void [5]

What makes Into the Void interesting are two things. First, it is located at Bluewater, the huge and innovative retail world in Kent, England. Bluewater insists that all retailers commission the services of a designer. Second, the owner did not have deep pockets but wanted to use the exterior of his stores to position Into the Void as a unique brand offering contemporary comics and fantasy toys. The end result relies heavily on a very graphic structural treatment, strong branding and the use of a polycarbonate skin over a galvanised steel structure, backlit with ultraviolet light. If you occupy the fantasy world of graphic novels the exterior leaves you in no doubt that you are entering the right environment.

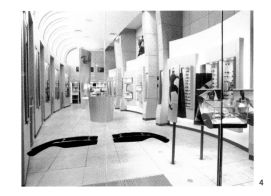

4

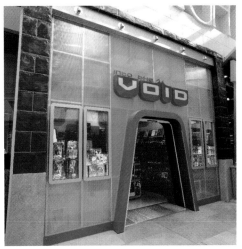

5

Client Selfridges
Design North
Location London, UK
Date 1999

03 INTERIOR SIGNAGE

A customer walks into a store.

He stops to look around and find the store's floor map which he then studies in detail, locating the exact whereabouts of the departments or products he is after. He then takes time to orientate himself in the store and read the signage so that he can find what he is after on the floor he is on. On entering a department he similarly stops and takes time to understand the layout and read the display headers so that he knows where everything is. Finally he locates the product he wants and walks straight to the till to pay for it, having already ascertained where it is.

As any retailer or designer will know our customer, like the unicorn, doesn't exist. Consumers simply don't behave in this way. They may be in a hurry, 'time starved' and starving, or distracted by children demanding attention. They may be disorientated on first entering the store and just strike off in any direction, hoping to find what they want. They may simply enjoy dawdling through the store exploring its contents.

Understanding that customers don't always behave in a logical, rational fashion affects the way interior signage is designed. It places great emphasis on the need to simplify information, to make it immediate and meaningful and to make it impactful. Good interior signage works well when it supports the information it features. It also works best when there is a clear strategy behind the information featured and considerable thought about what information is meaningful to consumers.

Store Directories – Selfridges [1]
Selfridges occupies seven floors and totals one million square feet of retail space. To help customers navigate the huge space, and orientate themselves while on a particular floor, North designed 360 directional signs and these are strategically sited around the whole store. They also designed 700 fire and safety signs sympathetic to the scheme.

The key to the design is that they are all vertically oriented pieces of unique, stylish product design, which combine presence and approachability with a limited footprint. The signs stand on an aluminium core which is bolted to the floor, and two polycarbonate sleeves are mounted on top of this base. The simple graphics, combining easily understood department titles with directional arrows, are applied to the inner face of the two sleeves, to keep them out of the reach of fingers tempted to peel off the lettering.

The signage is also supported with a hand-held store guide, which complements the system.

Contemporary
Menswear

1

Childrens
Sport

↖

Retail Graphics
Interior Graphics

Client John Lewis Partnership
Design In-house Sign Designer
Location Kingston, UK
Date 1990

28

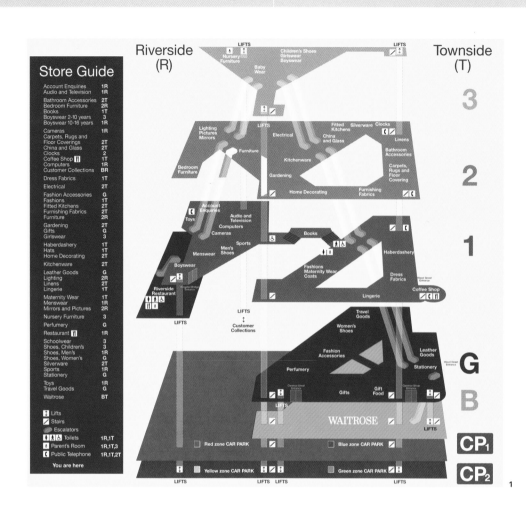

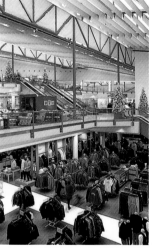

Store Maps – John Lewis [1/2]

John Lewis' Department Store in Kingston is a dramatic space constructed of different levels linked by escalators and lifts. In many ways it is unlike 'traditional' department stores with their full-length, equal-sized floors. Instead, John Lewis has floors of different sizes and shapes, and galleries giving views across the whole store.

Visiting the store for the first time could be a potentially disorientating experience so John Lewis has placed store maps strategically around the store (for example, next to the lifts from the underground parking) to help customers find their way around and locate the department they need.

The maps are designed to reduce the store's layout to a simplified, easily understood form; they use colours (based on different tints of John Lewis' corporate green) and grid references to help customers distinguish between floors and locate individual departments in the store guide. Universal icons are also used to pinpoint services and accentuate the location and destination of lifts.

Client K-Rauta
Design Allen International
Location Turku, Finland
Date 1999/2000

→

Store Maps – K-Rauta [3/4/5]

K-Rauta operates stores in Finland, Sweden and Estonia. Traditionally they were builders' merchants supplying the professional contractor, but in response to a changing market they developed their proposition to increase their appeal to the softer, consumer-oriented side of home renovation, while still holding on to their regular customers.

Considerable time was spent by their designers, Allen International, planning out the store which was based on a central event area focused around six departments: Kitchen, Lighting, Bathroom, Living, Sauna and four different consumer groups: Builder, Professional, Renovator and Pleasure Seeker.

All this planning culminated in a store directory and map featured at the entrance to the store. Simplified to numbers, text and colour-coded departments the map enables customers to find exactly what they want and then navigate the store using high-level department indicators. Numbers featured on the map are also repeated on the end of shelving runs. The store directory, department and aisle signage all use blue, while yellow was used for all service and advice elements, such as information stations and staff uniforms.

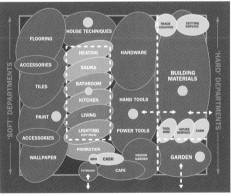

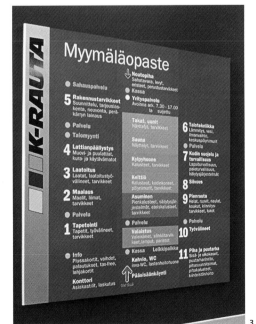

Retail Graphics
Interior Graphics

Client Selfridges
Design Pentagram
Location Manchester, UK
Date 1988

30

Store Directories – Selfridges [1/2/3/4]

When Selfridges opened their first store outside London in Manchester they commissioned Pentagram to design a signage system to help consumers visit and enjoy the two floors of merchandise. Their solution consists of free-standing store directories, sited at key decision-making points in the store, constructed of brushed stainless steel and glass. The directory graphics are screen-printed onto carrier material which is then applied to the reverse of the glass. Each sign also has accompanying portable directory maps, available from holders mounted on the signs, for customers to use while in the store.

The signs work on two levels. Firstly, they provide customers with a summary of all departments, facilitating a quick scan for the area they need. Secondly, they provide a map of each floor enabling customers to pinpoint the location of the department they want. Interestingly, colour coding for the different departments is not reliant on a key that customers have to reference. Instead, it simply reinforces that there are different departments and locates each within the floorplan.

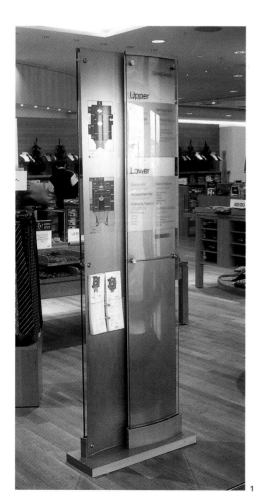

1

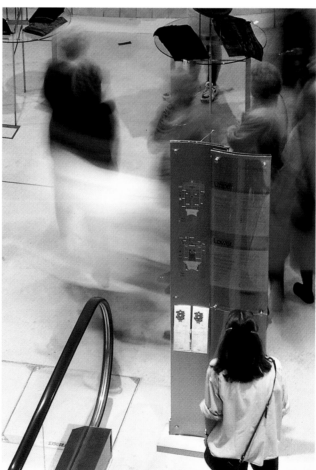

2

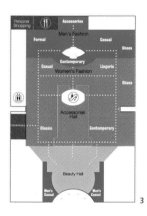

3

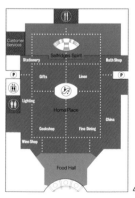

4

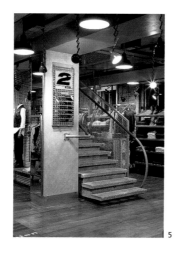

5

Floor Guides – Dr Martens [5/6]

Red or Dead's design for Dr Martens' floor
guide combines good siting with simple, clear
graphics. The main store directory is right next
to the store entrance and is then repeated
on a pillar next to the stairs on each floor.
These signs use the Dr Martens' corporate
colours of black and yellow and combine strong
typography with icons to help customers find
what they want. Designed out of 'industrial'
materials they are sympathetic to the look
of the whole store, created by Din Assosciates.

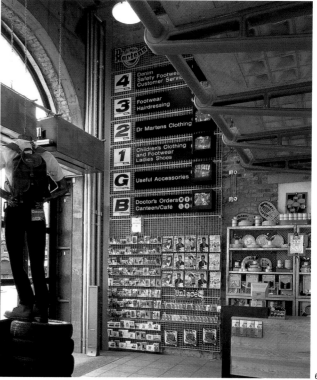

6

Retail Graphics
Interior Graphics

Client O'Cool
Design Imaginif
Location Drongen, Belgium
Date 1998–1999

32

Product Locators – O'Cool [1/2]

As an alternative to words, icons (like these used by O'Cool to identify different product areas in their supermarkets) need to be immediate to be effective. They need to work at a glance, be universally understood and should require no interpretation.

Benefiting from the uncluttered space between the ceiling and the top of the low-level fixtures O'Cool's icons have a powerful eye-catching effect. Designed in double-sided and four-sided configurations the signage is a highly visible consumer-friendly device.

1

2

Client Prudential Property
Portfolio Management
Design Noble Associates
Location Coventry, UK
Date 2001

3

Floor Signs – West Orchards [3/4]

The signage system for the West Orchards shopping centre in Coventry combines floor indicators with floor information. They enable visitors to identify where they are in the building of three floors of retail outlets and four floors of car parks. Designed in the shape of a triangle and constructed out of folded acrylic with satin stainless-steel trims the oversized signs are lit from the inside so that they glow. The signage is designed to have a strong sculptural form, reminiscent of the pop sculptures of Claes Oldenburg, so that they become a feature of the shopping centre environment.

The signs also feature icons detailing the services and facilities, such as public toilets, available on each floor. All the graphics are applied on the inside of the folded acrylic to keep them safe from vandalism.

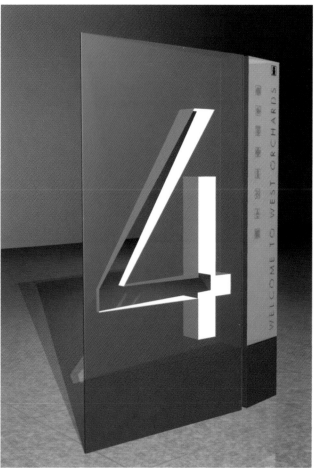

4

Retail Graphics
Interior Graphics

Client Halfords Limited
Design Lippa Pearce &
Din Associates
Location Gateshead, UK
Date 1999

34

Department Locators – Halfords'
'Auto Arcade' [1/2/3]

When Halfords trialled their 'Auto Arcade'
concept they used large coloured pillars and
emotive black-and-white photographic friezes
to identify and locate the individual departments.
These pillars, visible throughout the store, each
features a different colour. First-time visitors
see not only the name they want but the full
range of product areas available, the colours
highlighting the number of different departments.
Return visitors can use the pillars as reminders
of the location of the department they previously
visited, or locate a new one.

The friezes, using photographs of products from
the department's inventory (such as alloy wheels,
audio components and auto accessories) not
only help identify the departments but add
drama to the perimeter of the supercentre's
wall, their sheer scale commanding attention.

Client Homebase
Design 20/20
Location Dundee, UK
Date 1999

→

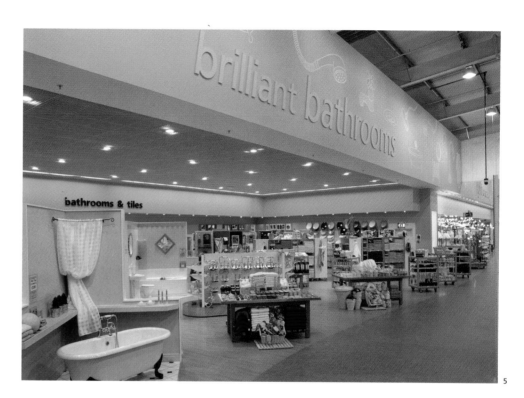

5

Department Locators – Homebase [4/5]

Like the Halfords 'Auto Arcade' project,
Homebase uses large-scale departmental
identifiers to overcome the scale of its
superstores and achieve impact, clarity and
personality. Combining 'straight' communication
of a department's content with a more emotive
tone of voice the large bulkhead signage
employs typography and imagery to
communicate directly with consumers. Like
a proscenium arch they also frame the theatre
of the product merchandising.

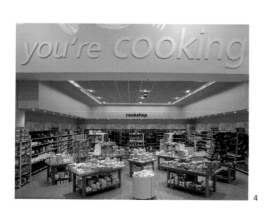

4

Client Lakeland Limited
Design Lumsden Design Partnership
Location London, UK
Date 2000

36

Section Headers – Lakeland [1/2]

Lakeland's graphics illustrate how many retailers use their fixture headers to identify individual departments, such as Kitchen and Garden, and individual product lines within a department. In their case they have employed colour to segment the departments and combined these with a round motif featuring a section-related icon. Interestingly this segmentation is repeated on their in-store home-shopping website display material – a true integration of 'clicks and mortar'.

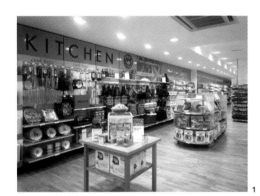

1

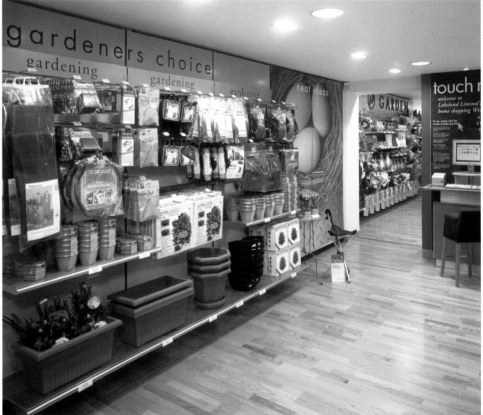

2

Client Etos
Design 20/20
Location Netherlands-wide
Date 1998

Section Headers – Etos [3/4]

Etos is the number two drugstore in the
Netherlands. Their new, larger specialist stores,
at 300 square metres, twice the size of their
normal stores, contain four product category
worlds: Beauty, Bodycare, Health and Baby.
Each of these worlds has its own environmental
personality and tone of voice.

Much of this personality derives from the use
of emotive, uplifting imagery on in-store signage
and merchandising. At a product level the
imagery is also used to identify different product
sections such as Vitamins, Aromatherapy,
Tissues and Deodorants. Larger sections like
Hair Colouring and Hair Styling use simpler
typographic bulkhead signage.

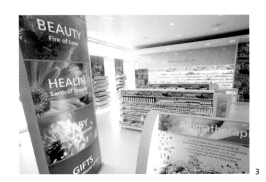

3

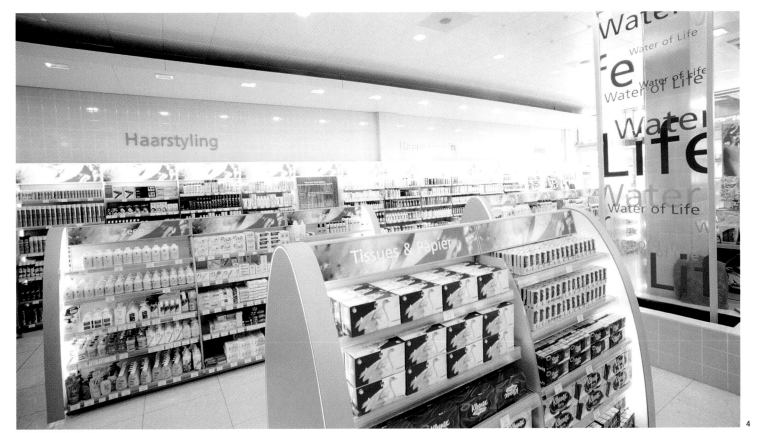

4

Client De Bijenkorf
Design Virgile & Stone
Location Amstelveen, Holland
Date 1998

04 MERCHANDISING AND DISPLAY

The novelist E. M. Forster once wrote 'Only connect', a highly pertinent sentiment for anyone connected to retail design.

Only by understanding a retailer's core customers can one hope to create an environment conducive to them. Only by understanding a retailer's core proposition, its values and personality can one hope to create a store that reflects these, and which is sufficiently different and attractive for consumers to try it and prefer it. Only by connecting with their customers can retailers hope to engender interest and loyalty.

Clearly a retailer's wares play a vital part in attracting customers, just as the way the store is designed and laid out. Mums with pushchairs will hardly struggle up to the third floor to get their babies' new nappies if there is a store on the same street selling them on the ground floor at the same price. Yet we have all known when we enjoy visiting a store. It may be because of

the service or the range of products, but equally it may be because the environment is right. The place 'talks your language'. It is interesting, relaxing or thought provoking. It may reflect you, like Pure, or share your interests and concerns, like Body Shop. It may, like The Wiz, provide you with a totally new shopping experience, one you find infinitely better than any previous one.

The selection of merchandising and display examples overleaf illustrate how a number of different retailers have analysed their customers and tried to make a connection through one aspect of their retail graphics – their merchandising and displays.

De Bijenkorf [1]
De Bijenkorf, Holland's leading department store group, is committed to offering its customers fashion from the top end of the market. As part of a new and dynamic store atmosphere, large-scale graphics were created to communicate the excitement, activity and glamour of the 'fashion show' and to provide the store with a house fashion identity. These graphics use the imagery of a fashion show and integrate them with display features like catwalks and cosmetic testing bars. The photographs themselves were shot by fashion photographer Niall Mclerney.

Their use of graphics shows how important siting and editing is. The display at the top of the stairs is a strong example of how the graphics have been used cleverly in the architectural context. The image draws the eye up the stairs and invites investigation. Given the amount of white space the temptation would be to fill it. Instead the designers have, true to form, revelled in the white space and the effect is all the more powerful for it.

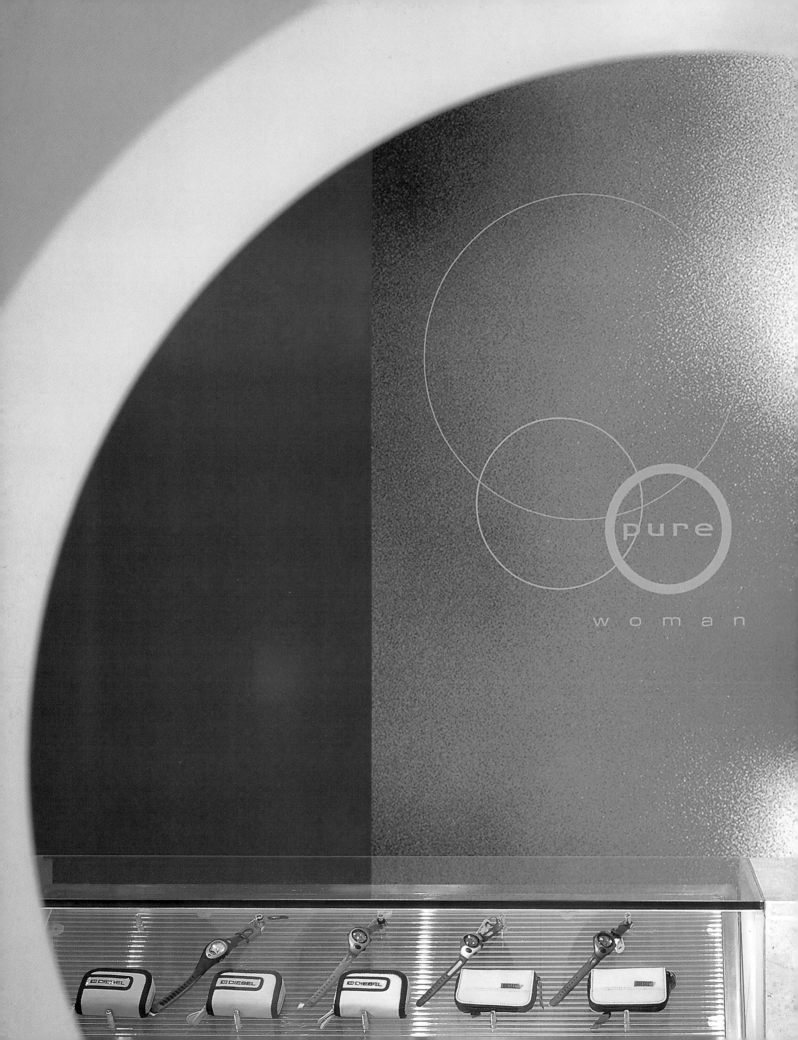

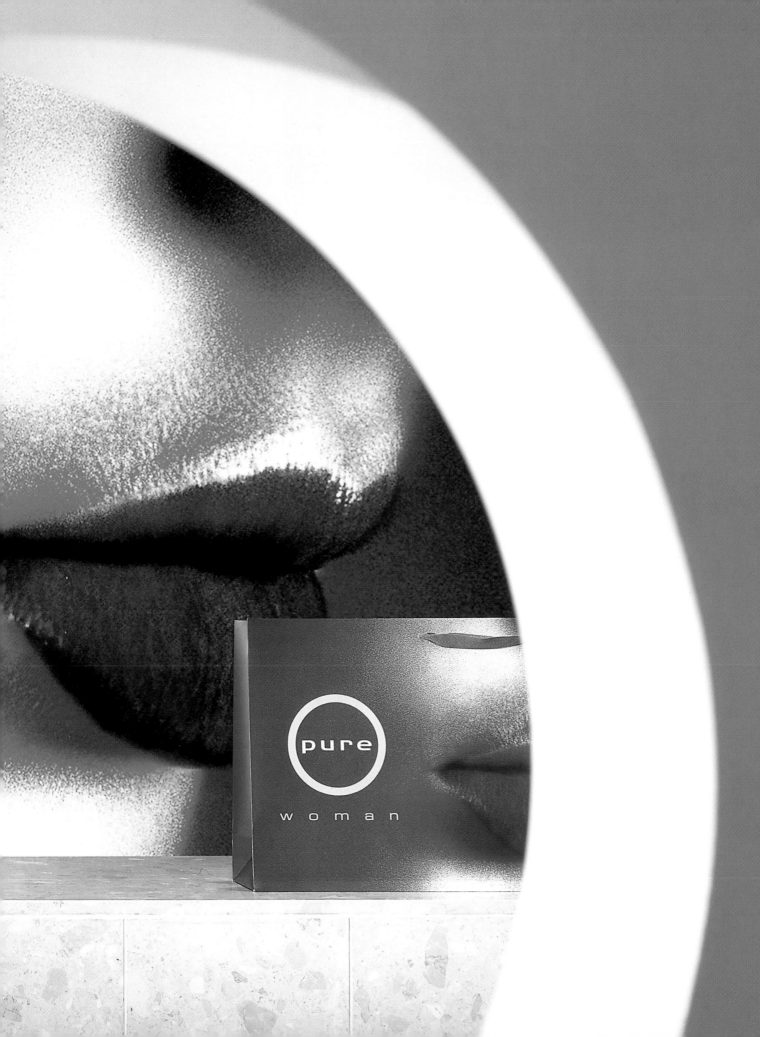

Client Blacks Leisure Retail
Design Journey
Location Bluewater, Kent, UK
Date 2000

42

Brand Communication – Pure [1/2/3]

Pure Woman represents one of the new breed
of stores which has been designed primarily
as a lifestyle brand with a defined set of values
and a clear insight into the expectations and
demands of its target consumer: the style-
conscious 20- to 30-year-old female.

Both the store itself and the graphics designed
to support the Pure Woman brand concentrate
on communicating fashion, style and elegance.
The focus is on creating distinctive defining
features that consumers will associate with
the brand. In the case of the store a unique
shelving system was developed which answered
stock display needs but with minimal visual
impediment to the consumer. In the case of
the graphics, powerful, highly stylised imagery,
used in conjunction with the brand's visual
identity, provides the store with focal points
and a strong personality.

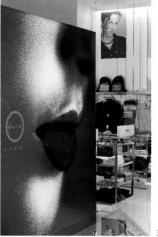

Client Debenhams
Design Debenhams Design Team
Location Manchester and Leeds, UK
Date 1998

→

43

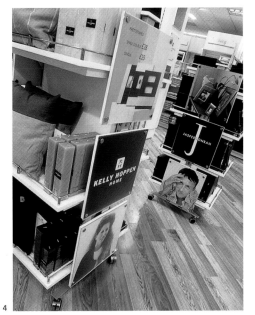

4

5

Brand Promotion – Debenhams [4/5]

We live in a brand-obsessed world and for many consumers their choice of retailer is determined by the availability of the leading brands at a particular store. Communicating brand availability and choice is therefore an important part of product merchandising and display.

These two examples from Debenhams illustrate two responses to brand promotion. The first, from Home Furnishings, maximises the impact of both the designers' names and their public image. The second, from the Sportswear department, integrates the brands' well known visual identities (namely, their logotypes) into a whole wall, where they work alongside the products themselves, video monitors and large-format lightboxes.

In both cases the merchandising of these brands seeks to gain maximum impact and visibility from their treatments – both at a close range and from a distance.

Client Berean
Design RPA
Location Canton, USA
Date 2000

44

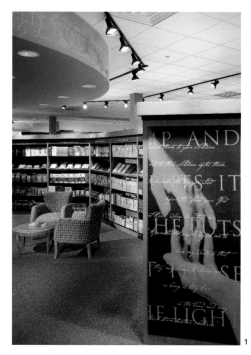

1

2

4

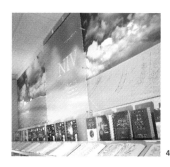

3

Environmental Graphics – Berean [1/2/3/4]
Berean promotes fellowship, knowledge and
ministry and its store is designed to be accessible
to all people. Throughout, it employs graphics
to communicate to its customers and create a
welcoming environment. These graphics, whether
large-scale treatments of walls, movable graphic
panels, end-of-shelving displays or illustrated
wooden cubbies featuring bestsellers, take their
inspiration from the Bible and promote Berean's
commitment to spreading the Word of God.

Despite the different graphic display types,
and occasional changes of tone (for example,
positional brand graphics for the youth area) all
reflect a quiet, measured directness and a focus
on the inspirational source – promotion with
a quiet voice.

Client Randstad Belgium
Design Imaginif
Location Belgium-wide
Date 1999–2000

→

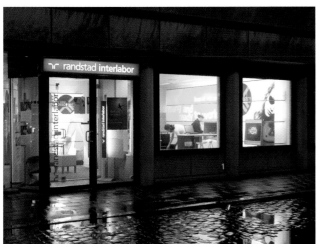

5

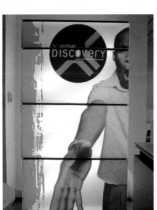

7

8

6

**Environmental Graphics –
Randstad Discovery [5/6/7/8]**

Randstad is the market leader in the Belgium temporary labour market, with 20,000 temporary workers, 17,000 clients and 130 branches spread across the country. Randstad Discovery is targeted at young people, from 16 to 26 years old, who are looking for temporary employment during vacations or the school year.

Given the heterogeneous nature of the target group, with different sub-groups and different stages of psychological development, the challenge was to create a new offer (from a virtual community based round a special website to on-line job offers, from 'first experiences' to tips for applying for jobs) and a different brand image and experience to Randstad's other branches.

Randstad Discovery's displays play a major part in differentiating the sub-brand and in creating a dynamic and relevant image for the target market. Based on a fusion of different influences, such as the cyber and technological worlds, the large-format displays employ contemporary imagery in an arresting fashion. Coupled with distinctive messages and integrating technology such as TV monitors, the different graphics invite interest from passers-by and communicate the attitude and relevance of the brand to youngsters looking for temping work.

Retail Graphics
Merchandising and Display

Client The Wiz
Design RPA
Location New York, USA
Date 2000

46

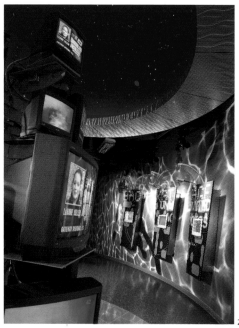

1

2

Environmental Graphics – The Wiz [1/2]

Today's electronic stores tend to be boring and backward, redundantly merchandising products on monotonous runs of gondolas, where you find a product, a graphic with a picture of the product, and the brown box it came in. RPA's goal was to segment the product by zones, create visual accessibility and give the consumer control by getting products into their hands. The Wiz wanted to change the customers' mindsets from selling electronics to selling home entertainments by altering consumers' attitudes and stimulating their senses.

The Wiz is a sophisticated user of graphics within interactive touchpoints, on product 'shields', on large utility obscuring panels, and on cashwraps. In many cases these graphics serve a specific commercial objective but RPA also persuaded The Wiz team to use graphic images (such as an exploding light bulb, a ghostly human face pointing a remote control at the consumer and an old-fashioned perforated metal microphone) to create a mood for the store – a mood which is perceived as innovative, entertaining and engaging to consumers.

Client Discovery Channel
Design FRCH
Location Baltimore, USA
Date 1999

→

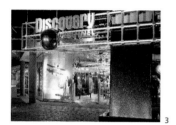

3

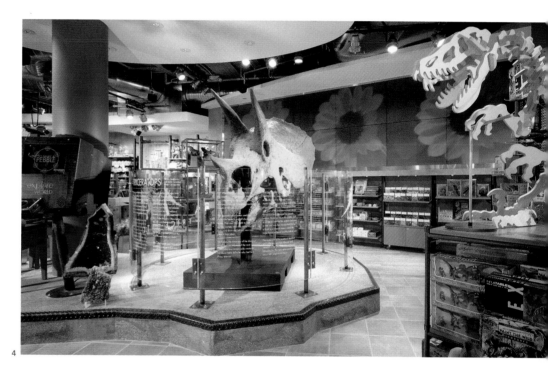

4

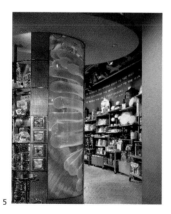

5

Environment as Experience –
Discovery Channel [3/4/5]

Discovery Channel's 6,725-square-foot store combines interactive features, arresting audio and video effects, museum-quality displays and a highly distinctive retail store design. Some of the more striking store features are the television sculptures that spiral from the ceiling to the floor, a giant media wall (20 feet long x 5 feet wide) broadcasting Discovery Channel programmes, Plane Spotter – a game that tests consumers' flying skills and an authentic 65-million-year-old Triceratops skull that is for sale.

Within this environment graphics are used to support the display of merchandise and contribute to the brand experience. For example, the Science Area is anchored by two attention-grabbing columns sporting rear illuminated images of nature and science. The other sides of the columns feature shelves for merchandise displays and built-in vitrines with magnifying boxes providing microscopic views of insects. The Triceratops skull is surrounded by glass panels providing a history of the dinosaur and graphics support other 'hear and touch' products and displays. All these graphic devices not only help educate customers but help reinforce the Discovery Channel's mission to encourage people to 'explore their world'.

Client Marks & Spencer
Design Holmes and Marchant
Location Tolworth and Oxford, UK
Date 1999

48

Departmental 'Dressing' –
Marks & Spencer [1/2]

The explosion in interest in wine means
that the average consumer is now much more
knowledgeable about wines and has a far more
educated palette when it comes to selecting
the right wine for a meal or an occasion. The
language of wines, in particular the flights of
fancy employed by wine experts to describe
a wine, is also something consumers are
increasingly familiar with.

Marks & Spencer's wine department dressing
reflects this. Using rich, evocative images it
conjures up many of the words used to describe
wines – 'a hint of raspberry', 'a suggestion
of honey', 'a soupçon of aniseed', 'an overlay
of grass'. Apart from adding visual interest
to the department these images convey
Marks & Spencer's own expertise at selecting
the best wines for their customers.

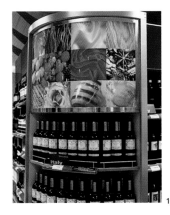

1

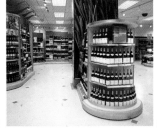

2

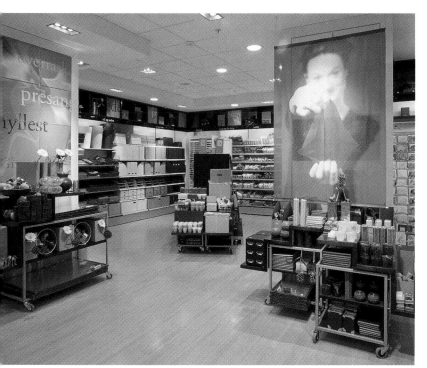

3

Departmental Differentiation – Libris [3/4]

Libris is Norway's largest chain of bookstores, each featuring a number of different departments: Books, Paper and Cards, Children, Youth and Office. It has recently undertaken a store refurbishment programme, masterminded by Allen International. One major component of this programme is the improvement of departmental differentiation and merchandising clarity.

The solution utilises a complement of light and dark hues to create a visual theatre of colour. Each department is designated a specific shade of blue, from cool pale blue for Books to dark navy blue for Office, combined with relevant and attractive imagery. This imagery is displayed on prominent graphic walls and helps communicate the department's contents. Each wall features an eye-catching photograph, in some cases with product messages given an interesting typographic treatment.

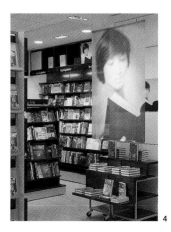

4

Client CAT
Design Cobalt
Location London, UK
Date 1999

1

2

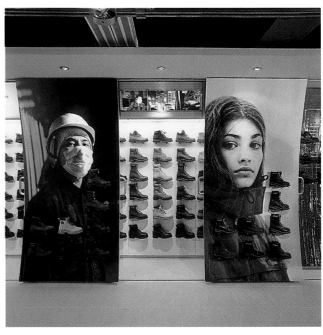

3

Range Segmentation – CAT [1/2/3]

CAT's footwear and workwear showroom
employs a very flexible merchandising device
which allows them to update their marketing
collateral every three months. Movable graphic
panels are magnetically backed to a curved
galvernised display, and these panels can be
removed easily and replaced with new images.

The large photograph shows how CAT uses the
panels. In this instance they are used to promote
two different ranges of footwear, one a men's,
the other a women's range. The magnetic quality
of the galvanised panel has also been used to
display the boots themselves over the images,
using magnetic fixtures. Between the
supergraphic panels the photograph also
illustrates how bulkhead lightboxes are used
to promote different aspects of the brand.

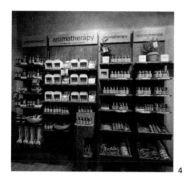

4

5

6

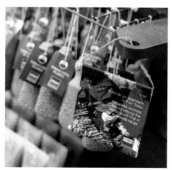

7

Product Merchandising – Body Shop [4/5/6/7]

Body Shop's merchandising of their natural products, such as Ayurvedic and Aromatherapy ranges, shows how product display, merchandising format and information communication can be integrated into a seamless whole.

Wood, ceramics, fabrics, plants, stones and corrugated cardboard were chosen to create a sensory experience for the customer, while their neutral colours and raw textures helped to reinforce the natural message. Plants and ingredients that can be touched help to tell product stories in a tactile way and encourage customers to interact with the fixtures.

Signage gives clear category information at a top level and more detailed product information at the shelf level. The graphics also have a strong informational role, communicating Body Shop's brand values, highlighting their points of difference and telling global ingredient and Community Trade stories.

In some cases the type was branded into the wooden elements and pressed into clay ones, giving the signage a tactile feel. 'Hero products' are highlighted by sitting them in stones with holes drilled in them. This not only lifts them away from the shelf but reinforces the product's natural message.

Client Dr Martens
Design Checkland Kindleysides
Location Europe-wide
Date 1994

Client Clarks
Design Pentagram
Location UK-wide
Date 1977

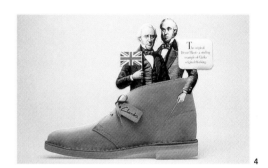

4

Point of Sale – Dr Martens [1/2/3]

Dr Martens are famed for their classic boots. Their basic utiltarian workwear has been a staple of work-force and youth-culture 'uniforms' for decades. Features like chemically resistant soles and reinforced construction add to their durability and comfort.

Their point-of-sale material communicates the products' functionality and strength in an arresting and engaging fashion. Basic corrugated board construction, bold typography and simple photocopy-style imagery combine in a quirky and fun manner. 'Footwear formula' and 'Construction' point of sale use laboratory test tubes and bottles to reinforce the science behind the soles and individual boot features. 'Urban', 'Classic', 'Street', 'Kids', 'Catwalk', 'Terrain', 'Open Airwair' and 'Steel' depict individual footwear characteristics. All feature consistent branding and a complementary colour palette to give a strong and uncomplicated visual style to the material, a characteristic of the Dr Martens' brand.

Point of Sale – Clarks [4]

In contrast to Dr Martens' point of sale with its detailed communication of products' features and benefits, this point of sale for Clarks is single-minded in it message. Clarks was founded in the 19th century and has a long-established reputation for the quality of its shoes. The Clarks' desert boot is perhaps their most famous shoe, constantly being rediscovered by successive generations since it was first designed in the 1940s.

Pentagram's point-of-sale design, a wonderful integration of graphics with the product itself, focuses on conveying Clarks' heritage and association with this footwear icon, and does this in an eye-catching and idiosyncratic manner.

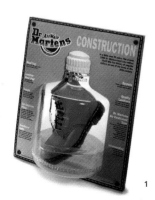

1

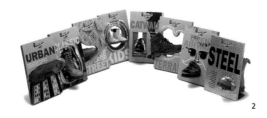

2

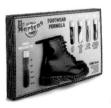

3

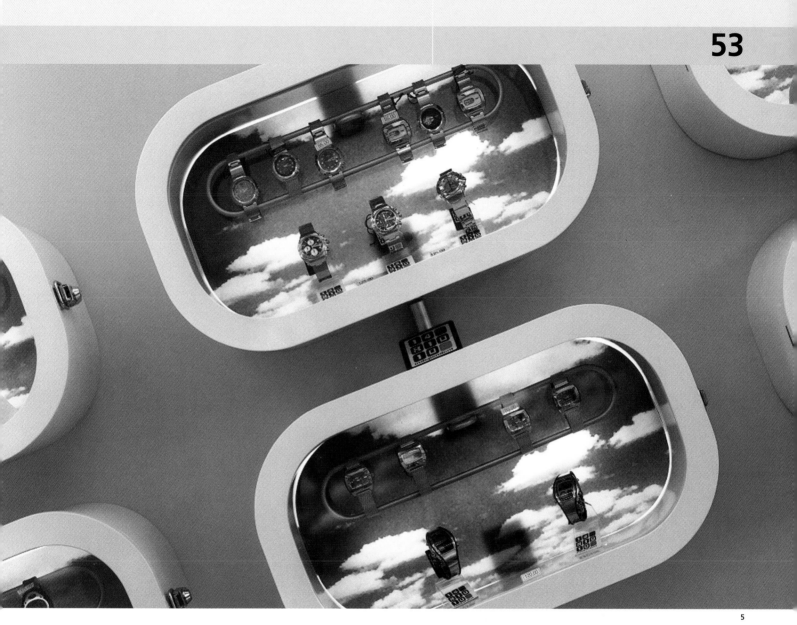

5

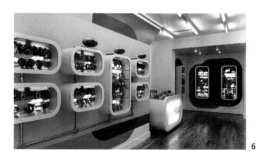

6

Display 'Dressing' – Face for Watches [5/6]

Face for Watches sells fashion-led watches to an 18- to 30-year-old market. Their stores feature the watches displayed upon bars within pods mounted on the store's walls. The graphic dressing of the back of each pod contributes to the overall atmosphere of the store, which is light and airy. The back dressing is highly flexible, enabling Face for Watches to change them and adapt them for each store to ensure the stores remain exciting and modern for their core market.

05 TAKE HOME

This book has deliberately not included own brand packaging – it's such a huge subject and deserves a book of its own.

It is concerned, though, with other 'packaging', what we have termed the 'take home' elements of a retailer's offer, like carrier bags, gift boxes and shoe boxes.

These simple things which seem to be grouped together by the ephemeral nature of their being (we get them home, take out our purchase and discard them) actually have other things in common, which increase their importance in a retailer's brand communication mix.

Firstly, for some of us, throwing them away is actually the last thing on our minds as we value them for themselves. Their construction or tactile nature pleases us. Secondly, as representative of a particular brand we display

them and keep them as status signifiers. Thirdly, their usefulness transcends the initial purchase so we hang on to them. In each case the very fact they no longer become valueless but valued means their ability to keep on 'communicating' with us is extended.

Over the course of time these common factors have become important considerations in the design of these items. As the examples overleaf illustrate the careful manipulation of these 'humble' retail elements has raised their design to a high art – an art in which the consumer is almost subliminally manipulated to perceive something about the retail brand that the brand wants to communicate.

The examples are clearly not an exhaustive selection of the different types of 'take-home designs', just some of designs that have caught my eye.

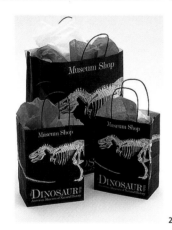

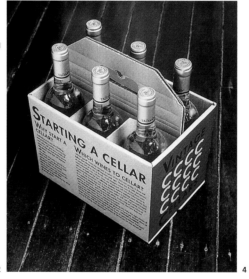

1. Reinforcing brand associations
Client Louis Vuitton
Design Michael Nash Associates

2. Tyranny on the streets
Client American Natural History Museum
Design Pentagram

3. Visual colour metaphor
Client Space NK
Design Michael Nash Associates

4. Message with a bottle
Client Vintage Cellars
Design Landini Associates

5. Distinctive chintz
Client Uth
Design Michael Nash Associates

6. Flirty and desirable
Client The Boots Company
Design Williams Murray Hamm

7. Quality hallmarked
Client Marcus
Design Pentagram

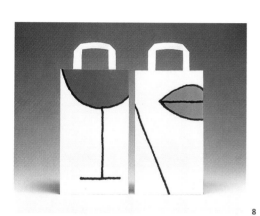

8

10

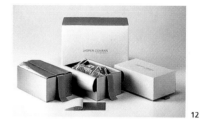

12

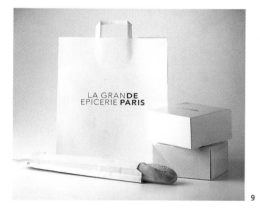

9

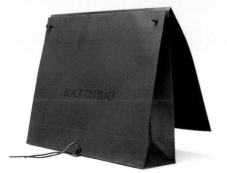

11

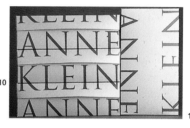

13

14

8. Sensory perception
Client Vinopolis
Design Lewis Moberly

9. Provenance emphasised
Client La Grande Épicerie de Paris
Design Lewis Moberly

10. Tradition questioned
Client Egg
Design Michael Nash Associates

11. Black on Black
Client Nicole Farhi
Design Din Associates

12. Designer statement
Client Jasper Conran at Stuart Crystal
Design Lewis Moberly

13. Elegant lines
Client Anne Klein
Design Pentagram Design Inc.

14. A bird in the hand
Client Bluebird
Design Studio Myerscough

Client	City of Cleveland and
	National Football League
Design	RPA
Location	Cleveland, USA
Date	1999

06 WALLS, CEILINGS AND FLOORS

The need to make an impact and attract consumers' attention often challenges retailers and designers alike.

In response, their attention often turns to the very fabric of the building and how it can be exploited to communicate and provide visual excitement.

Walls, ceilings and floors become 'canvasses' to apply graphics to, either permanently or temporarily. Usually the scale of these features provides the opportunity to produce visually powerful solutions, as evidenced by the work illustrated. Often practical considerations dictate the solution or they encourage designers to think laterally and devise new solutions based on new ways of looking at the client's objective.

Yet scale doesn't necessarily mean cost, the normal quasher of good ideas. New printing methods and new large-format production techniques have opened up a whole new world of opportunities. Both Uncorked and Burger King have achieved impact with their wall graphics yet neither is quite what it seems: etched glass or painted mural. And neither has done it at the expense of the budget or the quality of the finished effect.

**Stretched Fabric Banners –
Cleveland Browns [1]**
When the Cleveland Browns built a new state-of-the-art 1.64-million-square-foot stadium they included a retail outlet, bar and grill, and hall of fame as part of the complex. It was designed to provide a place where die-hard fans could express their team spirit outside of the bleachers and share their passion for National League football.

The 12,000-square-foot space was dauntingly big and continuous. Without focal points and floor to ceiling dividers it could quite easily lose visitors wanting to shop, eat and drink and watch the game on video monitors, or visit the hall of fame.

One of the solutions was to employ huge floor-height panels celebrating the Cleveland Browns, and showing the fans their team in all its past glory. These images, sourced from the Browns' archives and sepia-tinted are gussetted to giant beams. Like a huge signpost these banners form a hub around which the retail paraphenalia can be ranged. Lit to dramatic effect they become part of the excitement and visual splendour of match days.

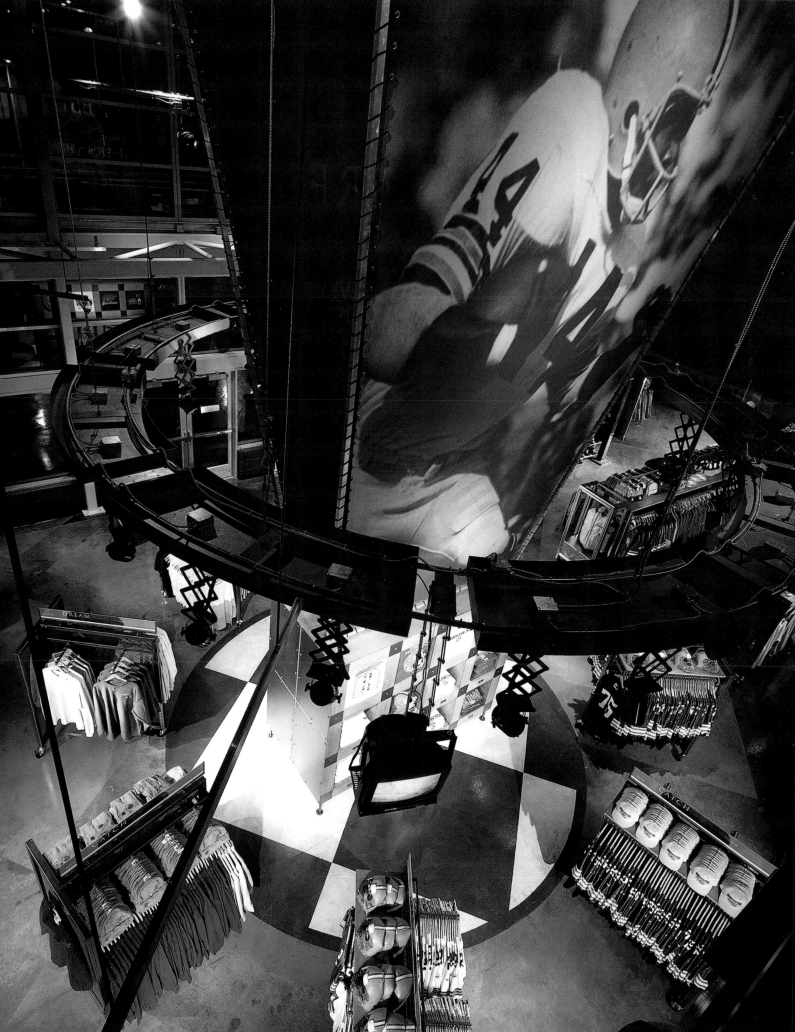

Client Uncorked
Design Fern Green Partnership & Karen Wilks
Location London, UK
Date 1999

60

Friezes & Screens – Uncorked [1/2]

Uncorked sells wine by the case so only a small selection of bottles are on display at any one time. Graphic imagery is therefore used to create visual interest and to inform customers about the range of wines available. A long frieze runs down the length of one wall and is set flush into the rendered surface finish. This frieze contains images of wine region maps. Interspersed along the frieze are images of wine, grapes and wine-making which are production-screen-printed on to glass and laid over the maps. These images are used to evoke the sensorial experience of wine – its smell, taste and look.

Graphics are also used to interesting effect on a full-height glazed screen to the offices at the rear of the space. This office space needed to be reasonably private but also to provide partial vision into the front of house. The solution was to apply an etched-glass-effect film to the glass with the names of grapes printed clear out and therefore providing vision through the glass.

In both cases the graphics have a clear communication function; they proclaim the expertise and knowledge of the retailer, and are also an integral part of the environment.

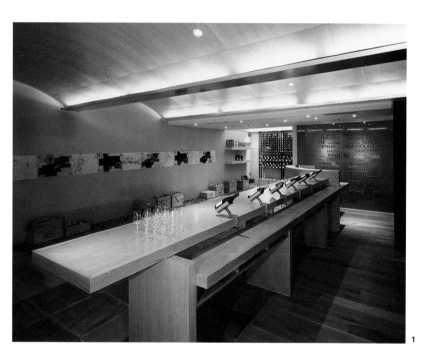

1

2

Client	Amsterdam Airport Schiphol
Design	Virgile and Stone
Location	Amsterdam, Holland
Date	2000

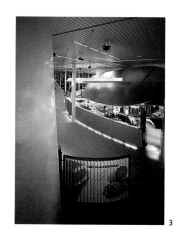

3

Screens – Schiphol Airport [3/4]

Amsterdam Airport's Central Lounge contains five retail pods and four food offers. Each pod incorporates graphics designed to address the needs of both rushed passengers in need of quick information and clear signage and those with more time to linger and be entertained.

Transparent layers of graphics on glass panels along the exterior of the fashion and media pods illustrate the content of each area while allowing views through to the retail space beyond. Picking up on aviation, travel and Dutch themes wherever possible, these layered images shift over one another as the customer passes.

The curved delicatessen gates have fins, which make the image fully visible from one angle while also allowing views through to the walls behind.

This fusion of communication but accessibility is a hallmark of this project. The designer, Virgile and Stone, has demonstrated a sophisticated ability to achieve the maximum effect from the space and the two-dimensional graphics, so that the walls, while defining the space and providing a large canvas to attract passengers' attention, do not obscure the temptations lying behind them.

4

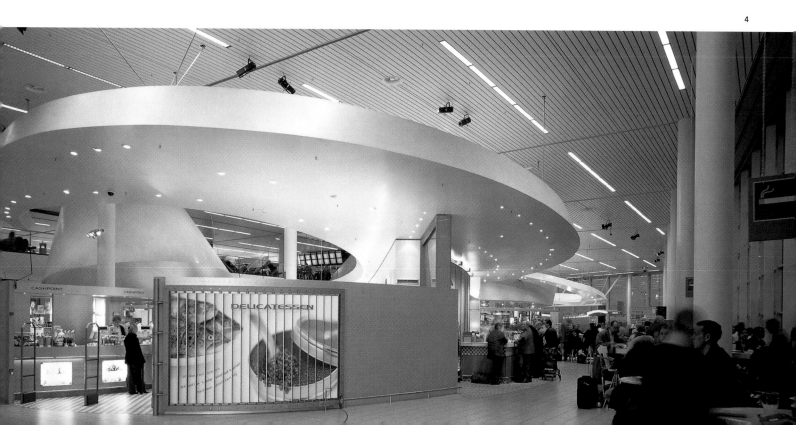

Retail Graphics
Walls, Ceilings and Floors

Client Cotswold Essential Outdoor
Design Lumsden Design Partnership
Location Glasgow, UK
Date 1999

62

Large-Format Displays – Cotswold Essential Outdoor [1/2]

The aim of the Cotswold Essential Outdoor store in Glasgow was to bring the outdoor clothing and accessories market to a wider and more fashionable audience. These customers demand more than just an 'anorak' shop. They want information, guidance and entertainment. The store answers these needs by artfully combining environment, product, graphics and merchandising display tehniques.

Among the products on offer are a number of different experiences: for example, a 12-metre-high display system, which allows customers to sample a bivouac experience; a display where customers can test stoves by brewing their own cup of tea; and a mezzanine boot area where shoppers can test the footwear by swinging on ropes and climbing a simulated rock face.

In some cases the graphics help customers navigate the store and segment the range but as the boot area illustrates they also contribute to creating the right environment and the feeling that the retailer knows what outdoor pursuits are all about. For avid hiker or casual walker this image of sore feet also brings life to the utilitarian, industrial-warehouse-feel of the mezzanine floor. More than anything, it brings the outdoor experience indoors. Its sheer size makes it unmissable at ground floor and mezzanine level.

2

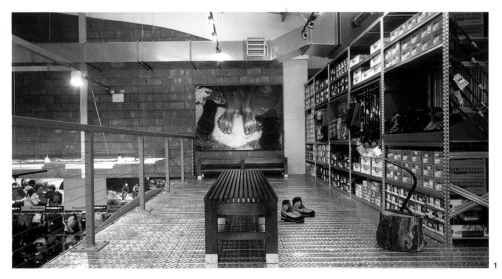

1

Murals – Burger King [3/4]
This mural, designed by SCG, was created to refresh Burger King's UK restaurants. It uses bold, strikng, graphic images taken from 20th-century Americana to provide a strong visual focal point and help create an environment reminiscent of a diner. The graphic images, consisting of photographs and illustrations, have been enhanced to brighten them and prominently feature Burger King's corporate colour palette of red, blue and yellow.

Designed to be flexible enough to work across Burger King's portfolio of restaurants the mural is made up of modules, allowing different configurations of numbers and formats depending on the architecture and seating arrangements of the individual restaurants. The mural's modules are digitally printed and then mounted on to MDF, and these are then fitted together with some of the images layered to give the mural a three-dimensional effect.

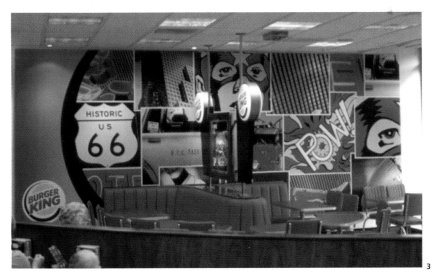

3

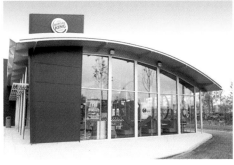

4

Client Warner Brothers
Design Jon Greenberg & Associates
Location New York, USA
Date 1998

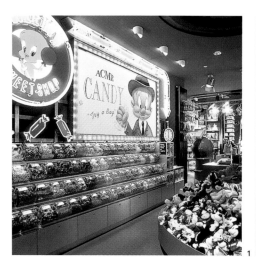

Lighting Treatments – Warner Brothers, One Times Square [1/2/3]

Warner Brothers' 15,000-square-foot store on Times Square sells branded adult and children's apparel, fashion and home accessories, toys, gifts and collectibles. The concept is a provocative exposition of the excitement and entertainment of the Warner Brothers brand. It is deliberately brash and colourful – much like the 100-year history of Times Square itself.

Each floor is saturated in a different colour, with intense colours used on floors, walls and ceilings. It is also a tumult of neon signs and different lighting effects. Mixing three-dimensional neon signs with a montage of popular Looney Tune characters in Broadway-style, classic 40s' neon, the whole environment is a visual feast of colour, words and images. The massive glass frontage, rising three floors, accentuates the whole effect further, bringing the theatre of the inside outside on to the street. The method in the visual 'madness' therefore serves a purpose. It brings the theatrical to the retail by exploiting the brand's rich image-based past.

Client Kraft Foods International
Design Landor Associates
Location Dusseldorf, Germany
Date 2000

→

Brand Walls – Campus Cafe Society [4]

Kraft Foods International has launched a major youth marketing campaign, designed to increase the appeal of its portfolio of European coffee brands amongst the under-25 market. The initiative, designed to make coffee a preference amongst 18- to 24-year-olds, is based on the creation of a campus café environment, designed specifically for the student market.

One of the features of these cafés, and the unique mobile café modules, is the inclusion of 'brand walls'. Made up of reportage-style shots of campus life and featuring real students these walls continually evolve via direct input from the students themselves. Every year the new intake of students will be photographed and then featured in the walls. The walls thus become a reflection of the students' lives and coffee a corollary of those lives. The graphics are modular in format to allow different configurations, and in the case of the mobile modules are internally illuminated.

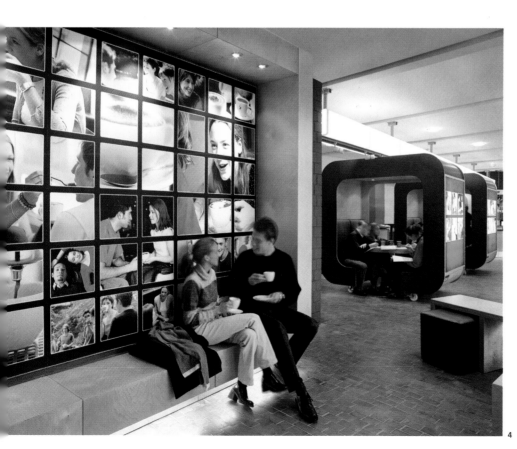

4

Retail Graphics
Walls, Ceilings and Floors

Client B&Q
Design SCG
Location Warrington, UK
Date 2000

66

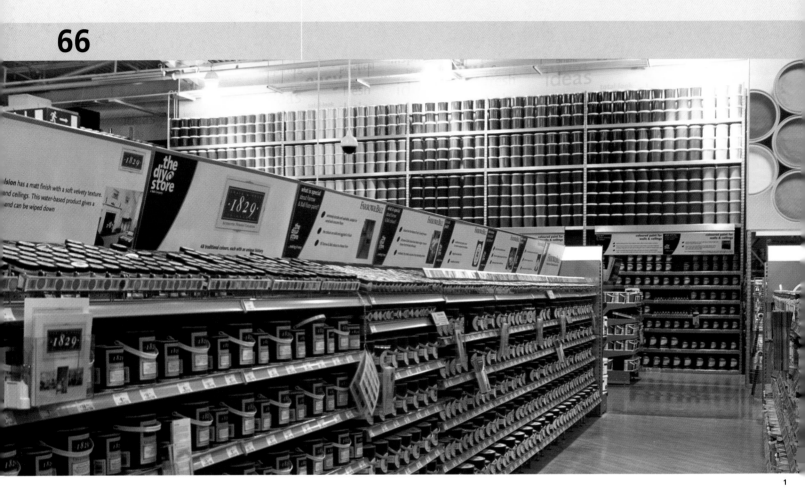

1

Wall Features – B&Q [1]

DIY sheds are not usually paragons of architectural vision or models of aesthetic beauty. Typically they are large open-plan sheds with high perimeter walls, visible utilities and unattractive sheet roofing. If there is any design benefit to be gained from this format it's from the uninterrupted canvas the walls provide at high levels.

B&Q has seized this opportunity with alacrity. Their dramatic display of paint cans, almost a paint chart as installation piece, is a powerful visual statement. Made up of colour-coded transparent paint cans the feature starts above the normal fixturing and extends to a height of three metres.

Running parallel to the store's 'raceway' the paint wall acts as a focal point and helps consumers navigate the store. It also helps define the Paint World and differentiates it from the other 'worlds' within the superstore: Lighting, Flooring, Windows, Home Store and Hardware & Fix It.

On top of the visual impact of the wall the display also communicates the breadth of B&Q's paint range. It advertises that whatever you need to do the job they have it and behind the wall B&Q have located their paint mixing department. To me the success of this feature lies in SCG's recognition that the scale of the wall afforded them the opportunity to think big – here size really does matter.

'Message Carriers' – Ch'a [2/3]

As a refreshment, tea bars compete against the highly developed coffee bar market as well as pubs and wine bars. But tea has a very different history to coffee, particularly coffee personified by the US coffee shops. This different history, and the fact that for the British tea is an icon symbolic of our way of life, is used to bring Ch'a, a new tea bar, to life.

Tea-based imagery is used throughout the store, from specially designed lights to teaspoon door handles, from leaf shapes as a common motif to quirky, humorous quotations about tea used to support the personality of the brand.

These quotations illustrate the use of walls as subliminal message carriers; namely tea as an intrinsic part of our lives. The tea-based quotations are placed judiciously where they can be seen, for few can resist looking at themselves in a mirror and many enjoy the discretion mirrors offer when people-watching.

Other projects, like Warner Brothers, show how a cumulative effect can be gained from using almost all available wall and ceiling space. Ch'a illustrates how the selective use of walls as message carriers and the careful editing of these messages to give them space to work can be just as effective.

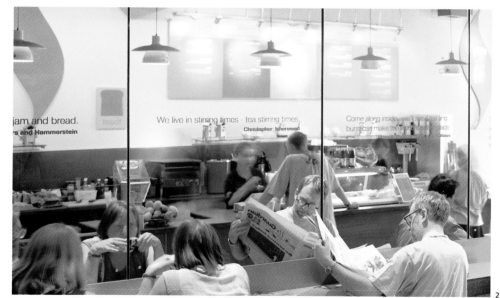

2

3

Client Ingredients
Design Rodney Fitch
Location Lakeside, Thurrock, UK
Date 2000

68

'Message Carriers' – Ingredients [1/2/3]

Ingredients is a unique concept based around the theatre of an artisan bakery which has revived the art of good bread-making. It offers a range of products baked on the premises. Consumers can watch bread being made, buy a coffee or a sandwich, and also purchase all the ingredients they need to bake bread at home.

Ingredients is about taste, good food and high quality products, and the walls, not to mention bulkheads, are a celebration of the concept's values and personality. The play on words, the use of emotive diction like 'love', 'spice up' and 'fresh' all contribute to consumers' appreciation of the passion behind the notion of an artisan baker. The scale of the wall displays mean they communicate to passers-by, to those waiting in turn to be served and to those enjoying a leisurely snack.

1

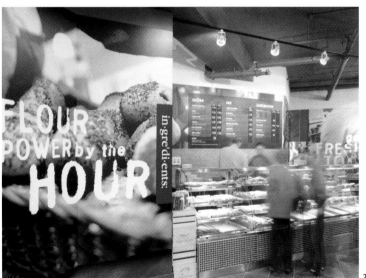

2

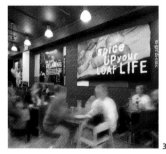

3

4

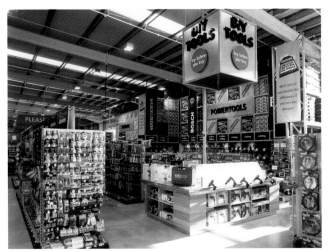

5

Floor Treatments – Homebase [4/5]
As this example from Homebase shows, floors can be used imaginatively as part of the overall graphics mix. Briefed to develop a distinctive 'Price Pledge' device which would form a permanent reminder of Homebase's commitment to low prices, Crabtree Hall's response was to make the medium support the message. They cast the message and inset it into the floor when the screed was laid. In the process they achieved maximum impact through size but without cluttering up the store entrance.

Homebase's 'Price Pledge' message is repeated on hanging banners placed strategically around the store; for example, in the DIY Tools section. This section illustrates how Homebase has also taken advantage of the shed's floor-to-ceiling height to create a powerful display combining range (brands are given prominence) and selection messages.

Client Waitrose
Design In-house Graphic Design Team
Location UK-wide
Date 2000

07 CUSTOMER INFORMATION

Customers often require assistance when they are shopping.

Many retailers know that providing this assistance can be a differentiating factor now that self-service is the norm. When the difference between products and services is negligible the service a retailer provides, the willingness to take a customer to the product they are seeking rather than direct them to the floor or aisle, can be the factor that customers remember and use as the reason to revisit.

Nothing beats the personal touch. We all know when we have been served well and we all enjoy it. Second to personal service the information a retailer provides can also be a measure of how much they care about their customers, and can go a long way to making a shopper's visit enjoyable and productive.

Sometimes we need information to help us select the right product, or understand what is on offer. As the T-Zone example on page 74 shows, choice can say a considerable amount about a retailer's expertise.

At other times we may just need inspiration (What should I cook for dinner tonight?) or to know that having finished our shop we can phone for a lift home. At other times customers may need distracting while their partner indulges in indecision, or much-needed refreshment after fighting the good fight in the sale bins.

In each case the provision of this type of information can lead to some very effective and interesting graphic solutions.

Customer Education and Inspiration – Waitrose [1]

I was shopping in Waitrose one day when I came across these credit-card-sized leaflets. I was so captivated by them I went round and collected every single one I could find. Each one is devoted to either a single fruit or vegetable and each credit-card-sized leaflet features a description of the fruit or vegetable, a serving suggestion, a tip (for example, 'Raspberries keep for a few days only, even in the fridge. Serving at room temperature brings out the full flavour.') and a recipe on the reverse. As a device to encourage customers to try something new, or buy produce they are familiar with, they are simplicity themselves but go a long way to demonstrating Waitrose's customer-focused ethic.

On the same trip my wife and I also saw a young couple with one of Waitrose's menu cards, studying it hard and working their way around the store finding the ingredients. To me their action seems a testament to the fact that this type of customer education and inspiration does work.

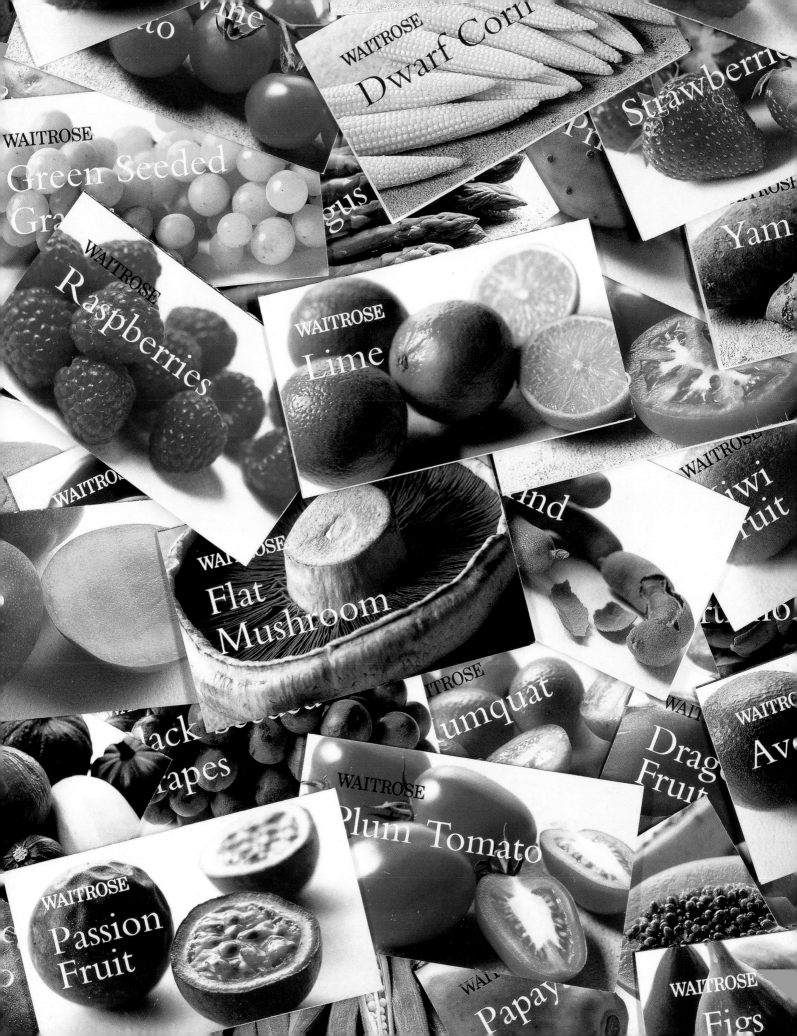

PATISSERIE

CHARGRILL

ICE CREAM

SALAD BAR

OMELETTES

Product Selection – John Lewis [1/2]

'Shop till you drop' is the clarion call of some but for others the chance to stop and enjoy a much-needed break is a must. This signage system, for John Lewis' The Place to Eat takes its inspiration from the sheer fatigue of shopping. A series of double-take images play on the way the mind drifts when tired: noodles becomes knitting, ice cream becomes golf balls, and salads become garden trowel and fork. The witty double-takes set out to raise a smile, so that visitors find refreshment for the mind as well as the body.

Many retailers' restaurants are bland and anonymous, lacking any personality. As a result they are often chosen out of necessity rather than preference. John Lewis' graphics encourage visitors to engage with their surroundings so that they not only help visitors find the refreshment they want but lift the whole concept by giving it a character.

SOUP & BAKERY

1

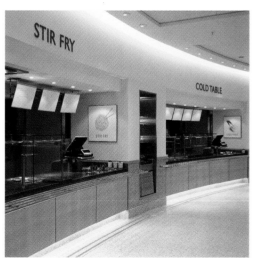

2

Client Whittard of Chelsea
Design Carte Blanche
Location London, UK
Date 1999

74

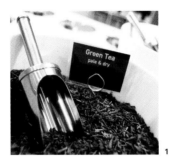

1

Customer 'Education' – T-Zone [1/2/3/4]

T-Zone presents a whole new approach to selling tea. Its aim is to make tea 'hip' and respond to renewed interest in tea as a refreshing drink with health-giving qualities. With over 100 teas on offer this specialist tea emporium could be too challenging to some shoppers. The fact that it is not, is a result of the skilful mix of interior design and graphic communication.

Carte Blanche's solution was to create a very cool, calm interior where graphics play a key role in lending visual clarity to the high-density product displays. Modular fixtures were designed to hold display boxes and were finished to directly reflect the three strengths of tea: off-white for light teas, cool green for medium and rich American-walnut veneer for stronger black teas. Above each fixture, clear reeded glass signs identify the tea categories, simplifying the customer selection process. Bold vertical graphic panels between the fixtures clearly explain the estate origin and different characteristics of the teas, as well as recommending ideal brewing times.

The selling area was designed to clearly segment the product for easier selection and to encourage customers to try a wider variety of teas. This is achieved both graphically and visually. The merchandise displays show the teas' diversity of leaf size, colour, texture and aroma whilst the activity areas are identified by simple product flags. A promotional tasting pod provides the opportunity to try new products and for the more adventurous there is a blending table where customers have the freedom to create their own mix aided by a specially designed recipe wheel recommending compatible blends.

The end result of the thought and consideration that has gone into the provision of customer information is an emporium where both the tea cognoscenti and the novice can shop and feel comfortable doing so.

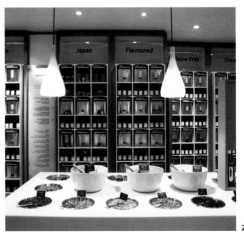

2

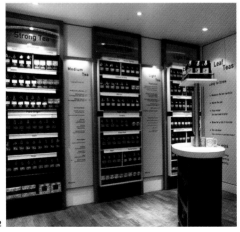

3

4

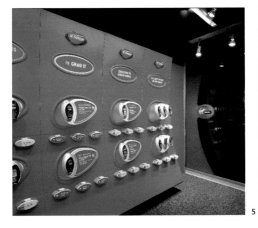

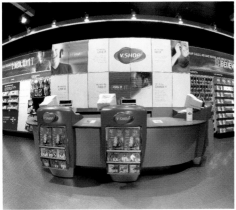

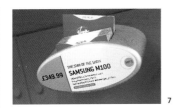

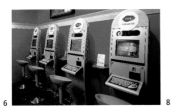

5 6 7 8

Product Selection – V Shops [5/6/7/8]

Virgin's V Shops set out to be a new benchmark in entertainment and technology retailing: a one-stop shop, offering the latest in music, mobile phones, visual media and everything to do with the virtual world. The stores set out to make the complicated simple and the enjoyable more fun. Large plasma screens catch the attention with a vibrant, ever-changing and instantly updateable multimedia sequence. Listening posts enable customers to hear any in-store CD by scanning its barcode. Purchases can be traditional, or virtual (by surfing a range of over 110,000 products at touchscreen kiosks for later home delivery).

Two features of the stores in particular illustrate how V Shops provide information and reassurance. On the 'red wall' the latest Virgin mobile phones are located on organically shaped display pods, set within backlit button-shaped forms. The red colour-blocked rear wall, a powerful reinforcement of the brand identity, provides a powerful visual focus within the shopfront zone, and pushes the products towards the customers. Customers are free to touch, feel and pick up the phones. Located beneath them are credit-card-sized pick-up cards, providing detailed product information for those looking to purchase immediately or consider their choices at home. The language is funky, active and encouraging.

The heavily branded cash desks provide customers with a wealth of information on large-scale display panels – from finding a product to trying it, from paying for a product to returning it – in easily absorbed messages which combine facts with enthusiasm. Read at the level of Hear It, Love It, Try It, Find It, Feel It and Change It the graphics communicate the brand's understanding of its customers' needs.

Retail Graphics
Customer Information

Client Sainsbury
Design 20/20
Location Greenwich, UK
Date 1999

Customer Service – Sainsbury [1]

UK consumers are very familiar with Sainsbury's orange brand identity, Recently it was refreshed to make it more innovative by developing a rejuvenated version of the colour 'Living Orange'. In new stores this brand rejuvenation finds expression in large-scale features like the wall of oranges and this becomes the backdrop to the communication of a number of customer services: payphones, taxi service, saving stamps, etc.

Customers paying for their goods at the till can quickly locate, peruse and select the service they need, assisted by the bold, large-scale icons using the brand colour palette of orange and blue. Here the siting takes full advantage not only of the clear customer access space created behind the tills but the time shoppers have standing in the queue to look for these services.

1

Client Oasis
Design Fitch
Location London, UK
Date 2001

→

2

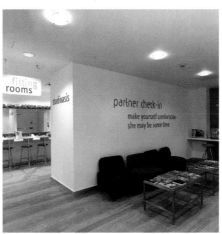

3

4

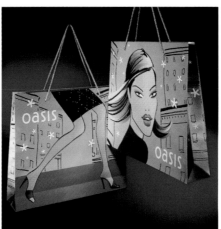

5

Customer Service – Oasis [2/3/4/5]

The Oasis brand is based on fun, spirit and emotions and their new London flagship store was designed to capture this spirit and make shopping the store a richer and more pleasurable experience. Recognising that it is the little extras which add value to the overall shopping experience, Oasis worked with the design company Fitch, to create a store focused on pampering, comfort, fun and entertainment.

In the fitting-room area friends and family can be left at Studioasis to relax and watch TV, read magazines or log on to the store's website while waiting. After leaving the fitting rooms shoppers can stop off at the beauty bar. They can grab a stool, and freshen up or reapply make-up and indulge in the store's own fragrance, before hitting the high street again.

What is interesting about Oasis's approach is the warm, friendly tone that the message is given by the use of wit. In turn the retailer's personality is developed. The message 'she may be some time' is refreshingly 'user-friendly' and recognises that the shopping experience is just as important for partners as it is for the purchaser. Often retailers stop short when designing and refurbishing their stores, leaving this sort of customer information out of the equation. Oasis illustrates that these sorts of elements are just as important. In his book The Pursuit of Wow Tom Peters refers to a carton of orange juice he once bought with the normal words 'Expire before' replaced with 'Enjoy before'. The positive effect the message, with its promise of satisfaction, had on him was significant. If only more retailers devoted time to the message as well as the medium – to developing a unique and distinctive tone of voice with a personality.

A major element of all retailing the world over is the seasonal offer.

Whether it's a sale or a specific promotion consumers now take it for granted that stores will feature a succession of offers during the course of the year when special deals will be on hand: Money Off, Three for Two's, Buy One Get One Free…

Traditionally the staple promotion has obviously been the sale, the selling off of moribund Winter, Spring and Summer stock. Like nature's cycle we now expect these events to come around. Over the years other seasonal events have become regular fixtures of the retail calendar: Christmas and Easter, Mother's, Father's and Valentine's Day. Consumers may grumble at the commercialisation of these dates but still feel duty bound to buy a card or present for their loved one.

For fashion retailers the sale which tails the season is topped by the promotion of the new season's look and retailers' windows are ablaze with this season's new colour, ironically normally determined many months previously, or this season's new look, as new shapes and cuts are rolled out or old styles refreshed. Whoever thought flares would return?

One major thing unites the communication of these offers – the need to grab consumers' attention quickly, simply and immediately. In some cases, as the page opposite demonstrates, this has led to an almost 'generic' solution. Whether the sale promotion is handwritten or printed the universality of red and the word 'sale' itself suffices. Except for a few exceptions no real attempt is made to relate the look of the promotion to the retailer's visual identity.

The examples from Selfridges, Waterstone's, Marks & Spencer and Warehouse illustrate another side to the coin. In each case the retailer has devoted time and effort to creating graphics which go beyond just promoting the event and communicate an aspect of the retailer's brand values or personality.

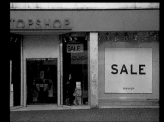

Retail Graphics
Seasonal Offers

Client Selfridges
Design Selfridges Design Team
Location London and Manchester, UK
Date 2000

80

Seasonal Fashion Promotions –
Selfridges [1/2]

The department store Selfridges is a house of international brands. It features the top international fashion designers in a wonderful environment and is a magnet for the fashion conscious. Its two promotions demonstrate a confident understanding of the power of simplicity, tone and creativity to capture consumers' attention. The New Season promotion 'borrows' the illustrative style of the haute couture designer – the singularity of line to express a form captured by the illustrator Stuart McKenzie.

Selfridges' Beauty Week poster is the embodiment of an idea (expressing beauty universally without recourse to an image consumers wouldn't identify with) given a reductive but delightful treatment. In this case less is definitely more.

1

selfridges beauty week
23 march - 1 april

Client	Warehouse
Design	Interbrand
Location	UK-wide
Date	2000

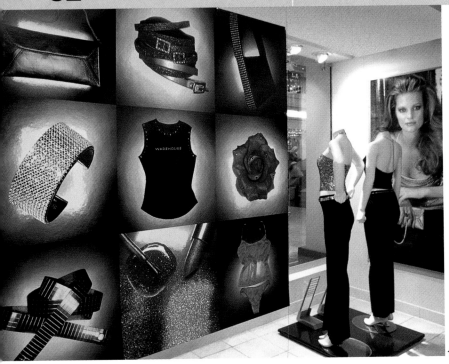

New Season's Lines – Warehouse [1/2/3]

In the highly promiscuous world of high-street fashion, where the consumer has little or no brand loyalty, brands, like Warehouse, have to fight hard for attention. Although it had an excellent reputation, in the business and with some of its customers, for getting fashion from the cat-walk to the high street, it had no distinctive tone of voice. Point-of-sale material and window displays were virtually anonymous and entirely led by the product rather than conveying any personality.

Warehouse's new retail graphics are now more distinctive and compelling, and have a brand 'hand-writing', evident in all of their in-store communications such as window panels and concertina showcards. In line with its brand values these graphics are more stylish, sensual and sophisticated. Among other things the brand's colour palette was enhanced to include metallic inks, in particular the use of silver with black.

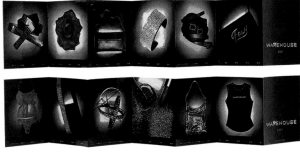

Client The Boots Company
Design Lippa Pearce
Location UK-wide
Date 1996

Client Marks & Spencer
Design Williams Murray Hamm
Location UK-wide
Date 2000

Happy Father's Day - 16th June

4

mothers day

sunday 2nd april

5

mothers day

sunday 2nd april

6

Fathers' Day – Boots [4]

Sometimes the visual busyness of a store environment can be off-set to best effect by the simplicity of a promotional treatment. In the case of this Father's Day promotion the simplicity is heightened by its reliance on typography and colour palette alone. Yet it is no less powerful because of the colloquialism of its language and the warmth of the witty solution. And not a shot of a pair of socks for Dad in sight.

Mother's Day – Marks & Spencer [5/6]

Just as Boots eschewed clichéd Father's Day imagery Marks & Spencer did the same – combining cropped images and lots of white space with a neat typographic twist to the same powerful effect. No beaming mums, no bouquets of flowers. Instead an image which communicates to both the potential purchasers and recipients of the gifts. Purchasers are reminded whose day it is and what Mum would really like – a lie-in or time without the kids for just a little while. For recipients it illustrates that Marks & Spencer understands what they really want and therefore is in touch with real life.

Retail Graphics
Seasonal Offers

Client Waterstone's
Design Lippa Pearce
Location UK-wide
Date 2000

84

Christmas Promotion – Waterstone's [1]

Despite the ever-changing pace of life there are some things consumers are still very traditional about. Christmas is one of them. I've worked on a number of Christmas promotions and each time research has shown that they equate Christmas with certain types of imagery and a definite colour palette. Deviate too far from this and they vote with their wallets. In one instance where we were positively encouraged to employ a very different palette to the red, green, gold, silver and blue consumers normally associate with the season the retailer experienced some quite vociferous correspondence from its customers sayng just how much they did not like it.

The Creative Director Norman Berry at the advertising agency Ogilvy & Mather says to clients 'Give me the creative freedom of a tightly defined brief' and this work for Waterstone's shows how, working within the constraints of a 'nominated' colour palette, it's still possible to come up with fresh ideas that are immediate and in the spirit of the season. They are also in keeping with the personality of the retailer, as evidenced by the wordplay in the strapline 'Gifts they'll still be opening after Christmas', because they take the traditional imagery of Christmas and give it a new twist.

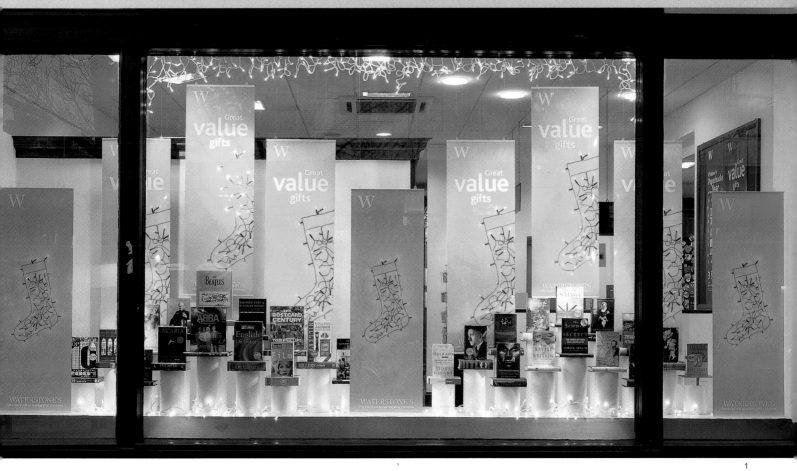

FASHION

Fashion retailing is characterised by diversity and polarity. Every taste is seemingly catered for from the avant garde to the mainstream, from haute couture to off-the-peg. At one extreme sit the fashion houses and designers with their collections for the rarified few. At the other extreme proliferate the retailers catering to the budget-conscious mass market.

It's a world where reason and emotion sit side by side, where different rules can and often do apply. It's a world where shoppers seek a huge variety of things, let alone clothes: inspiration, glamour, gratification, individuality or conformity, ease, status and even solace (for surely it's the origin of the phrase 'retail therapy').

For retailers seeking to position themselves in this heady world there is a lot to get right: branding, product, promotion, environment, price, and service. The way in which graphics play a role in branding, promotion and environment, in the central ground of fashion retailing, is explored here.

Etam and Tammy

Graphics' ability to influence the look of a retail environment is well demonstrated by 20/20's work for Etam and Tammy. Etam and Tammy target different customer types but are often located in adjacent areas within the same outlet.

Etam, which targets 25- to 45-year-old females, adopts a mini fashion department approach, with each merchandise department having its own unique environment and visual identity. Tammy is designed to respond to the rapidly changing needs and desires of a younger, more fashion-conscious customer. It does this by having event areas, promoting the latest look such as black patent leather skirts or pink fur tops, which punctuate the shopping journey.

As the photographs show, Etam [1] uses graphics in a far more subdued fashion, focusing on photographic show cards and display panels to promote individual lines. In contrast Tammy uses graphics in a far more dynamic, widespread and prominent fashion. It's also fair to say the graphics are used to define the environment strongly, and while they will be right for the core Tammy customer they will not appeal to the average Etam customer. One of the strengths of this project is that the retailer has not compromised and tried to create a total offer which appeals to both target groups and in the process satisfies neither.

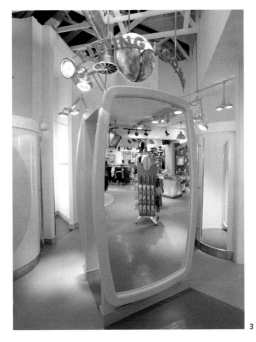

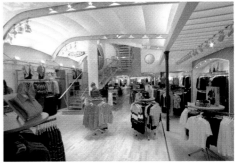

3

1

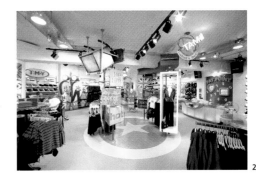

2

Starting with a brighter, younger more upbeat colour palette almost all areas of the store display graphics of some sort. Circular, starred floor graphics accentuate the event areas [2]. Pay point and fitting-room signage [3] employ youthful typography and funky icons. Ceiling-hung signage and graphic totems display 'street' language and imagery, such as red-hot lips.

The whole effect is a faster paced environment in which imagery and language focus on making the notoriously fickle younger customer feel that Tammy understands them. The use of language is particularly interesting because this is an area which can be difficult to get right – especially with any degree of credibility. 'What's in? What's out?' It needs a tuned ear and a finger on the fashion pulse. Yet the immediacy of the words is a compelling reason to use them.

Client Etam and Tammy
Design 20/20
Location Leeds, UK
Date 1997

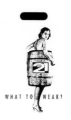

WHAT TO WEAR?

3

Rue 21

For some people fashion is a deadly serious business but does it have to be? Perhaps not when you are trying to create a store which will be attractive to value-conscious families looking for fashionable clothing and accessories. In Rue 21's case definitely not. They set out to create 'a fun place that's easy to shop'.

This has partly been achieved by the design of the store environment [1] which uses a warehouse conceit, complete with conveyor belt, wooden crates and other industrial props to create a distinctive look and feel for the store.

It has also been realised through the strong use of graphics. Much of the fun aspect of Rue 21 derives from these. The bright and cheerful colour palette, particularly the highlights of red and yellow, adds vibrancy and contrast to the neutral colours of the walls, floor and shelving, but most of all the witty use of retro imagery [2] as a 'signature icon' brings a strong personality to the store.

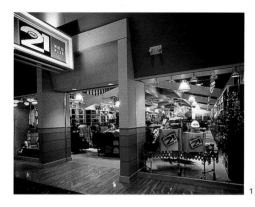

1

Whether highlighting the store's brand and value messages or headlining a display section, such as men's or women's clothing, the humorous use of retro imagery is a powerful brand-building device. The humour transcends age and sex, important when you are trying to attract a more mainstream customer base, and communicates in a very immediate way. It says this is not a store that takes itself too seriously – and we have all been in ones which do and felt intimated and uncomfortable.

It doesn't just end with the store's visual merchandising. Blade baffle graphics mounted on pylons, which define departments and divide the merchandise, carrier bags [3] and swing tags [4/5] all carry the imagery and corporate slogan, and continue the theme imaginatively. If only all retailers were as single-minded in their approach.

Garment Hangtags

4

5

89

Client Rue 21
Design Jon Greenberg & Associates
Location Auburn Hills, Michigan, USA
Date 1998

Levi's®

Perhaps a good place to start when talking about Levi's® flagship store in San Francisco is the brief they gave to their designers Checkland Kindleysides: 'to design multi-sensory retail environments which offer services and experiences that do not exist in any other retail outlet anywhere else in the world and to provide a new platform to showcase the best Levi's® brand product.'

Occupying 24,000 square feet on four floors the store offers customers an environment where fashion, music, digital audio and visual images converge; the objective being to create a dialogue with customers in the hope that it changes their perceptions of the whole Levi's® brand.

Containing features like a 100 x 35 foot storefront [1] which displays still-life images during the day and digital film work at night; a multimedia environment forming the backdrop for exhibiting work by today's emerging artists, with an exhibition space for artwork, sculpture and experimental work; Levi's® Original Spin™ featuring Body Scan technology which allows customers to design jeans to their individual style and fit; a warm shrink tub and human dryers for Shrink-to-Fit™ customers; a customisation area to allow customers to put their personal stamp on their clothes, such as laser etching, embroidery, heat transfers and hand painting; and biometric finger scanning technology which enables all of the audio-visual stations throughout the store to recognise a customer by name.

Client Levi's®
Design Checkland Kindleysides
Location San Francisco, USA
Date 1999

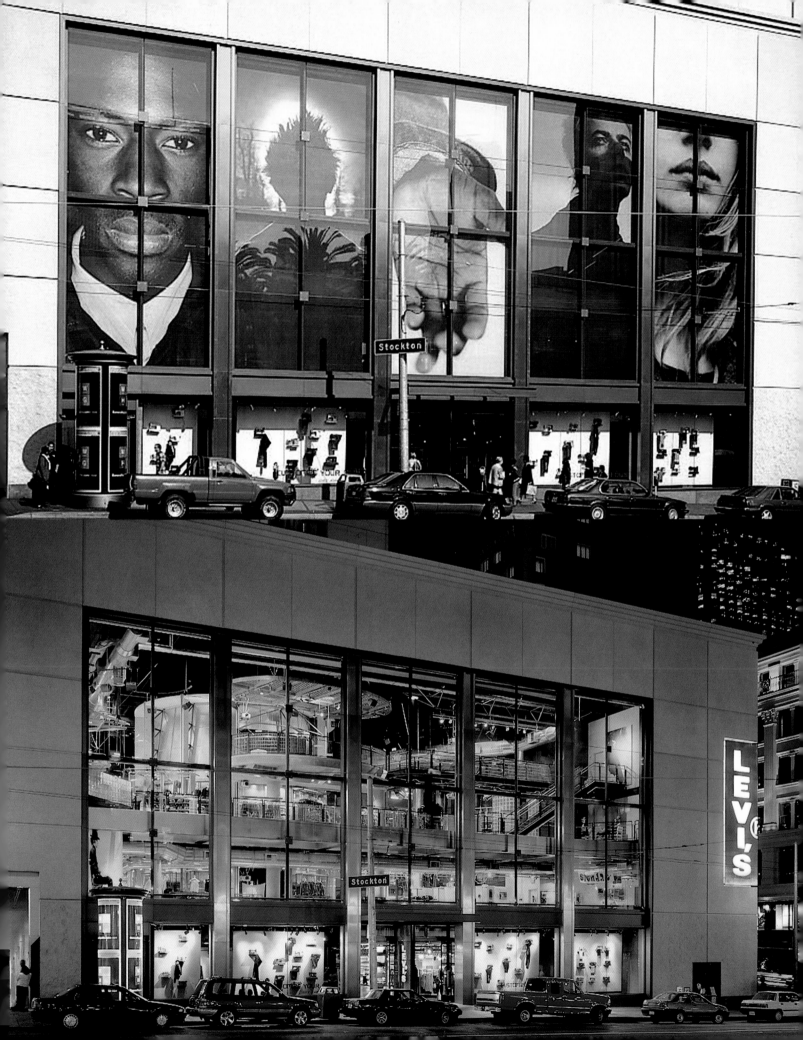

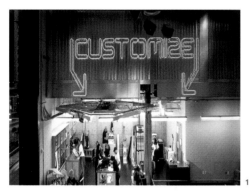

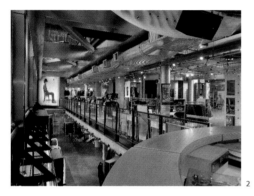

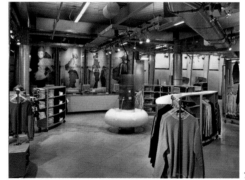

CUSTOMIZE

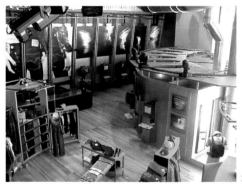

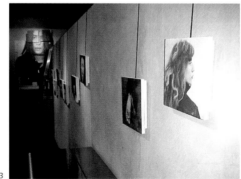

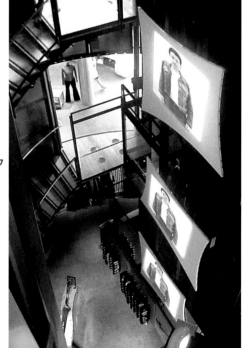

With such a large array of products, services, entertainments and information, one of the biggest challenges was to create an environment where customers would feel encouraged to travel throughout the whole store and explore all the floors, services and experiences. So while the various floors use a range of different materials (such as raw concrete, timber, oxidised and galvanised steel, natural copper and structural glass) and feature different services and products the graphics help with orientation and exploration.

Neon departmental signage [1], hero photography [2], product display panels [3], exhibited photography [4] and videos, interactive information consoles [5], department identifiers, store directories [6] – all of these elements are used in an imaginative and distinctive fashion.

As well as siting signage at key points in the visitor journey to help customers navigate the store (such as the typical siting of store directories next to lifts) signage like the neon 'customize' exploits the vibrancy of the medium itself (the vivid blue is in strong contrast to the muted tones everywhere else) and the iconic strength of the arrows draws attention to themselves from one floor to the next.

The choice of typography and icon styles reinforces the contemporary nature of the environment, using a fusion of visual language from a variety of sources: the music world, film and video, instructional manuals and digital art. In fact the store uses three purpose-designed typefaces – 'sign' was used for in-store signage, 'receipt' was employed on giveaway material, and 'net' was the system font that guided you through the store's many computer menus. In all three cases the typeface package was designed as a means of navigation, a more utilitarian store language which is different from the more emotional visuals.

Equally, photography and illustrations are used in a variety of ways – as a focal point for key services, such as pay desks [7] or Original Spin™, as product details and Original Spin™ graphic panels or in a modern gallery format [8]. This variety gives the whole environment a change of pace and saves the imagery from being filtered out of visitors' consciousness as they travel through the store.

6

SHOES

Germaine Greer once precipitated a very public spat with a fellow feminist when she described her protagonist's shoes in very unflattering and rude terms. Such was the power of the imagery that the women and the shoes became synonymous. In the '30s and '40s anyone wearing two-tone shoes was immediately considered a cad, a bounder, an almost certain correspondent in a divorce case – indeed they became known as correspondent shoes.

Our shoes define us as much as our clothes and in their own way G. H. Bass & Co., Ecco and Camper illustrate how these retailers have sought to align their products with the consumers' self-image: New England, eco-friendly, irreverent and fun-loving. Branding of course plays a significant part in this, as any edition of Vogue testifies, but the significant differences in use and style of graphics illustrates how these can be exploited to support the brand message.

10

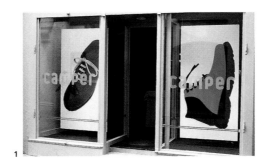

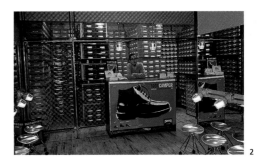

Camper

Camper originates in Spain and is synonymous with shoes of every taste and budget, and with what the company describes as a strong European designer 'impronta'. Its London-based shop is very simply designed with neutral colours on the floor and walls and a long white table with the shoes displayed on it. The only other shop features are the wheeled stools for sitting on while trying shoes on, pendant lighting above the table and the caged stock at the back of the store.

The shoes, rather than any merchandising and displays, thus become the focus of customers' attention. Reinforcing this focus are the graphics. From the large photographs of single shoes displayed either side of the doors [1] to the display panel below the stock room counter and the coloured shoe boxes in four tones [2], the graphics all support the central notion that the product is the hero.

What is more, the style of photography employed in the window displays and counter panel is highly idiosyncratic in its super realism and still-life quality. It's unmistakably different from other shoe retailers and this makes it doubly powerful. Like the other two shoe brands illustrated in this section, Camper realised that the brand's personality contributes just as much, if not more, to brand differentiation as its brand values do. Given that a brand's personality is often expressed by the 'clothes' it wears the graphics in this project play a lead role in defining it.

95

Client Camper
Design Neville Brody
and Fernando Amat
Location London, UK
Date 1995

→

gge.{sole}
= 2.9mm/acc.
w {heel supp.} @
w.p: 52.6mm (incl.
leather) w (sole) @
w.p: 83.75mm • e.s 97
l=258.5mm i.d=72 ~
support = 72∅ – c.j/b.s
upper shoe/2{xy}. stitch.
t {sole} = 4.4mm. ~ heel
incline = 20° raised heel
56mm {a.g.l} • a {sole}
= 11400mm² / a {heel}
= 170mm² is a {heel} =
{170/(170 + 11400)}%
of 100%. (t.s.a) « heel
centre = 50.65mm @
from shoe back ~ also
105mm from ball of
foot. wt. {shoe} = 173
gms. shoes tapers ~
max {w} ball * foot to
front. sole = i.m. nyl.
{x} ▼ inj. heel « via
‹2 spigots›. total
pmtr. of sole (l)
= 506 mm.

relaxing
awhile, briefly
conversing - fleet
afoot, base balancing
head - striding along,
beating quick rhythms.
dextrously controlling,
powerfully projecting.
softly ensconced, phalanges
smooching - dawdling slowly,
free form, lazy, syncopation
naked, brazen displays,
signalling intent - arching
gracefully, supporting
ambition - hiding desire,
caressing ever discreetly
sheathed synthetically,
skin u ion skin upon skin
stubbing nocturnally,
fibulaic pogoing - tapping
subconsciously, mind
tempted by the beat
entwined in passion,
on parade in repose
witness to momentum,
carriers of all of
our lives

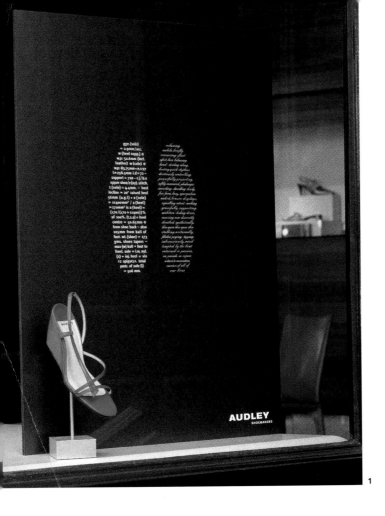

Audley

Audley is dedicated to producing an 'uncompromised design collection at affordable prices' and its adherence to this philosophy has resulted in distribution in a select number of international retailers, such as De Bijenkorf in Holland, and a very loyal customer base.

Audley stands for a number of quite distinct things. First, it is a shoemaker, and takes pride in designing and, perhaps uniquely, making them. Its shoes are contemporary in design and it produces extremely high-quality products, which have been designed to be pleasurable to wear. Audley's designs demonstrate an artistic and cultural sensibility – most noticeably in the architectural quality of its shoes.

Retail Graphics
Shoes

Client	Audley
Design	Lippa Pearce
Location	London, UK
	and Lisbon, Portugal
Date	2000

Above all the brand is idiosyncratic. It does things differently to its competitors like Gucci and Prada, and it likes to be discovered so that its customers feel they are one of the cognoscenti. For instance, Audley's London showroom is deliberately sited in a select 'old money' part of town which challenges customers' expectations of the types of shoes they will find there.

Audley's retail graphics support the brand's idiosyncracy and help communicate its 'subversive' and intelligent personality. Taking inspiration from the notion of the left- and right-hand side of the brain, its counter cards, posters [1], advertising, window graphics (see previous page) and tissue paper [2/3] employ two typographically rendered feet. The left-hand foot, the rational side, comprises a

scientific formula of the foot (: gge.{sole}= 2.9mm/acc.w {heelsupp.} @wp...). The right-hand side, the more emotional side, is a free-form, whimsical poem dedicated to the 'sensational' side of the foot ('relaxing awhile, briefly conversing...naked brazen display, signalling intent...witness to momentum, carriers of all our lives.').

The second campaign [4] in the retailer's series is an assortment of colour-coded squares, with linking key, which reveals to those who take the trouble to work it out a humorous poem about walking. Both sets of graphics illustrate Audley's commitment to producing stylish and elegant solutions, solutions which echo their approach to shoemaking and their attention to detail in the selection materials.

G. H. Bass & Co.

G. H. Bass & Co. has existed for over 120 years and is the inventor of the Weejun penny loafer, facts they remind consumers of in their brand identity. The Weejun moccasin derives its construction from the Native American canoe, hence their identifying icon [1].

Proud of its New England heritage, it has factories in Maine. The company recruited Pentagram to help rescue the brand from some wayward past activity which had seen poor-quality products being dumped in factory outlets. The company wanted to reafirm it as a brand with a strong heritage and a look synonymous with quality and New England.

The result is a strong co-ordinated retail brand identity which encompasses packaging, retail merchandising and 'take home' elements, such as shoe boxes and carrier bags.

This corporate image, (comprising visual identity, colour palette, product, craftsmanship and lifestyle photography and heritage imagery), has been used imaginatively and with rigour. Features like the Bass Last display [2] communicate both authority and offer. The imaginative use of the shoe boxes [3] and product packaging [4] help to tell the story of the brand while the display headers [5] 'lock' on to consumers looking for validation of the New England look.

Lastly, the carrier bags [6], often the first thing to suffer from budget cuts, work brilliantly as brand advocates – their quality and look providing a highly visible street presence.

6

3

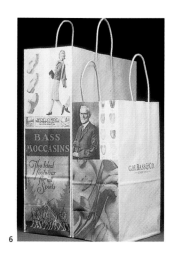

4

5

1

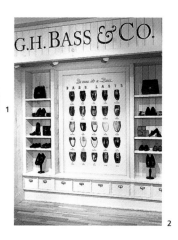

2

100

Client G. H. Bass & Co.
Design Pentagram
Location Paramus, USA
Date 1995

Ecco

Ecco, a Danish company, manufactures shoes of quality and comfort, with a reputation for lightness, softness and durability. Nature and technology are the inspiration for the design of their shoes and this is expressed overtly behind their pay desks as 'Our inspiration is nature and life.' [1]

Graphics take many forms within the stores: large-format window-display posters [2], modular-format display panels within a flexible display system [3], show cards of varying sizes and large-scale wall treatments. They are used to communicate on different levels, using the whole 'canvas' the store provides. This means the graphics are integrated into the product displays rather than being separate from them.

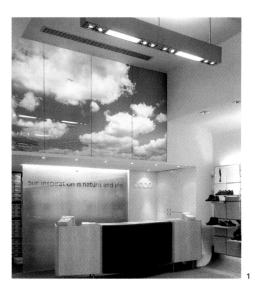

1

The window panels communicate product features within a technological or natural setting. The modular-format panels provide an infinitely flexible system for conveying style and mood while the show cards allow Ecco to introduce tactical promotions, such as the advertising of individual lines or the new season's look.

Given the brand's natural positioning the sky image is an important statement, supporting as it does the brand's inspiration and the use of other types of natural in-store dressing such as the sculptural bull rushes and the artful placing of stones in the window display. For consumers with a natural bent this type of imagery has a strong resonance.

3

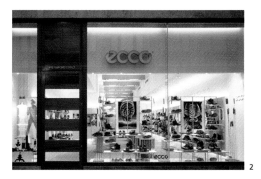

2

Client Ecco
Design Fern Green Partnership
Location London
Date 1998–2000

SPORTS

As the recent Olympic Games in Sydney testify sport is an international obsession. Millions are spent on national and international TV screening rights, and football teams, like Manchester United, make a healthy profit from selling the new season's football strip to their devoted fans – young and old.

This international obsession with sport is reflected in the number of international brands that belong to sportswear and equipment manufacturers and the development, in the last decade, of retail concepts like NikeTown.

As all of the case studies illustrate, sports stores are often inspirational environments where one comes to 'touch base' with one's sport, to find out what's new and to mix with like-minded sports enthusiasts, as much as finding a new pair of running shoes or a new piece of kit for your outdoor pursuit.

What is fascinating about Nike, Speedo® and Citadium is the way retail graphics play such a high-profile role in their retail environments. Perhaps this is because brand promotion is so important, whether it's a manufacturer's own or the range a retailer stocks. Or perhaps it's because many of the products they sell have product features and benefits stories to tell. Either way, many graphic treatments which are now commonplace in the retail world often start in the sports sector and migrate to other sectors.

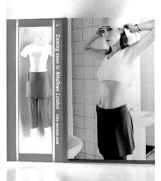

Nike

Some would say that if anyone had earned the right to be called the originator of the retail 'brand experience' it is Nike. Their famous Niketown in New York is a mecca for sportspeople, the fashion conscious and tourists alike.

One of the most prominent features of Nike's store designs is the use of graphics on a large scale, whether it's on the outside of buildings or as graphics on floors and walls. However, Nike is also an expert in using retail graphics [1/2/3/4/5] at a smaller, but no less innovative scale. As the work featured shows Nike has exploited the talents of its designer, Tango, to talk to consumers in a distinctive, interesting and interactive way.

Client Nike Europe
Design Tango
Location London, UK
Date 2000

→

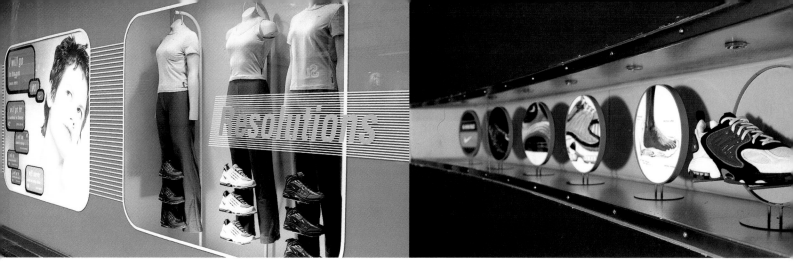

The window and merchandising displays **[above]** feature Nike's Alpha and Resolution projects. Each uses a very distinctive style to promote the projects' aims. Alpha, for example, aims to highlight their product research and development by talking in depth about how they develop products to meet the specific needs of the world's top athletes. Consumers are notorious for having very short attention spans and for not reading in-store information. Yet Nike's stories are often quite complex and in-depth.

Their answer lies in a combination of involving mechanics and arresting graphics. In some cases the graphics are used to intrigue and draw the eye, as in the case of the window display with its enticing 'portholes'.

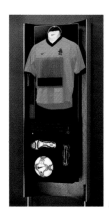
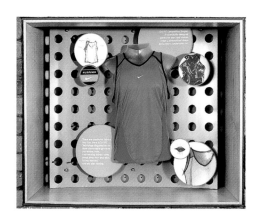

3

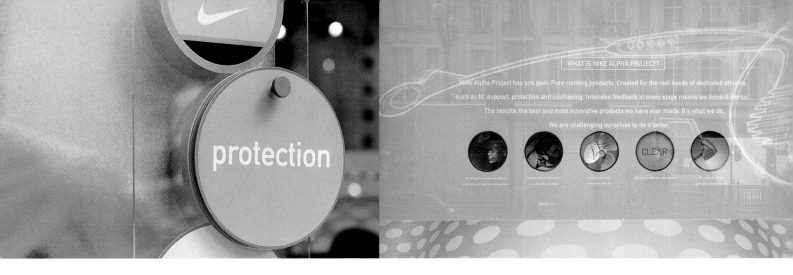

WHAT IS NIKE ALPHA PROJECT?

Nike Alpha Project has one goal: Pure running products. Created for the real needs of dedicated athletes such as fit, support, protection and cushioning. Intensive feedback at every stage means we know it works. The results: the best and most innovative products we have ever made. It's what we do. We are challenging ourselves to do it better.

CLEAR

The layering of information is particularly complex in this window treatment and often the siting of windows like these, near bus stops or busy meeting points for example, allows the designer to communicate more. In other cases the graphics provide detailed messages about the development of a particular product, dividing the story into easily digestible segments.

Sometimes the graphics focus on a particular product feature and benefit. Sometimes they support the mechanic being employed to keep the customer interested in the story; for example, the flip-over mechanic [1] discussing fit and other features. And lastly, sometimes imagery is used to convey a singular message such as performance in the way only visual material can.

What is interesting about Tango's work is the change of pace it achieves. On the one hand some displays focus on a very single-minded communication of one message and at other times the message is more complex and 'busier'. Yet the whole hangs together through the strength of the design vision, the use of repetitive devices (for example, the roundels) [2] and the interesting use of materials (for example, the use of clear plastic display materials which allow text to be overlaid on top of the product) [3]. This change of pace serves a clear function; it stops the graphics becoming nothing more than wallpaper and keeps consumers involved with the product…and the brand.

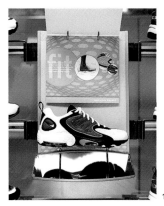

1
2

Speedo®

The world knows Speedo® as a swimwear manufacturer. In fact, they are the leading swimwear brand. Like most modern brands they are constantly evolving to meet the demands of ever more demanding and product-conscious consumers. The challenge they face is to keep consumers' perceptions of the brand in step with its most modern manifestation, which today means expertise in three distinct areas: Swim, Beach and Multisport.

Speedo®'s concept stores embody the brand's development and target a very broad range of customers from the serious sports person to the more brand/fashion orientated. They are much more than just a space for selling products. To coin a much-used phrase they provide a 'brand experience' wherein consumers absorb knowledge about the brand and its relevance to them.

This is achieved through the combination of imaginative interior design and varied graphic treatments. These are used throughout to

reinforce the brand's strong affiliation with the natural elements and its heritage of quality, science and technology. Overall the intention is to create an atmosphere of fluidity, lightness, cleanliness and coolness.

The store fascia [1] features an all-glass front, incorporating voiles printed with images of athletes which span the full height of the store and allow unrestricted views inside. The Speedo® logo, its spot red accentuated by the overall blue of the store, is featured subtly etched on to glass and repeated in colour on the handles of the store's entrance.

In-store graphic panels [2] are used to either reinforce the brand's relationship with water, the beach and sports, such as the image of competition starting blocks [3], or to communicate the symbiosis of nature and technology, which is at the heart of their products: 'Biometrics. Designed by nature, perfected by Speedo®.' [4]

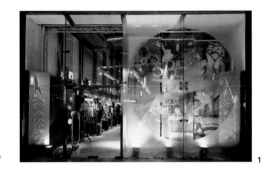

1

These static displays are complemented by 'benefit blades' [5], with their strong suggestion of surfing. These blades have a quite specific function; namely to educate consumers about the products' technical benefits, and in the process emphasise the brand's core values.

Coming from a packaging design background as well it's hard not to resist a mention of the merchandising and packaging for Speedo®'s Fast.skin [6]. Quite apart from being a wonderfully distinctive design the display is rooted in the product. Its moulded shape reflects the way swimsuits follow the contours of the body and the frosted plastic is reminiscent of water. The packaging achieves a masterly combination of brand differentiation, product delivery and irresistibility. Who could resist picking it up and exploring the contents inside?

106

Client Speedo®
Design Checkland Kindleysides
Location Bluewater, Kent, UK
 London, UK
Date 1999–2000

2

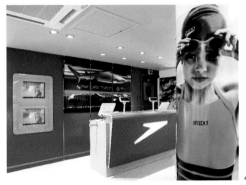

4

6

3

5

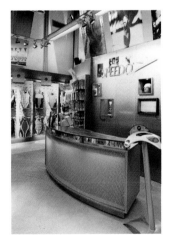

→

Citadium

Citadium is the world's largest urban sports store, occupying 9,000 square metres. Based in Paris the store features four flours, divided into Outdoor, Glide, Athletic and Street. Packed to the gills with departments catering for the needs of every type of sports person the store is also a treasure trove of the world's leading brands. On the Athletic's floor, for example, Citadium has Rugby, Running, Women's Sportswear, Dance, Football, Kids' Sportswear, Gym, Basketball, Cross Training, Swimming, Squash, Badminton and Tennis departments, and customers can find brands like Adidas, Converse, Dunlop, Fila, Head, Lacoste, New Balance, Nike, Puma, Reebok, Speedo®, Umbro and Wilson.

The exciting and broad range of products is complemented by an equally diverse and interesting range of modern and innovative retail graphics. These appear both on the dramatic exterior of the store **[1]**, throughout the interior and on branded items like carrier bags where the iconic strength of the retail brand identity is well demonstrated.

Floors are indicated by both large-scale signage **[2]** (the numbers and name of each floor visible at a distance) and by using the outer edge of each floor **[3]** in the central atrium where customers ascend or descend using the escalators. The name and content of each floor are clearly visible so that customers standing on the ground floor can see what is available on the top floor.

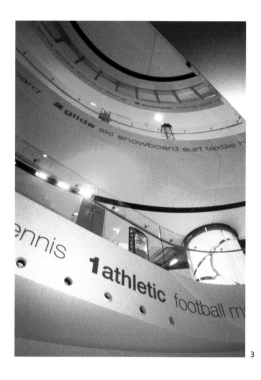

3

1

108

Client Citadium
Design Research Studios
Location Paris, France
Date 2000

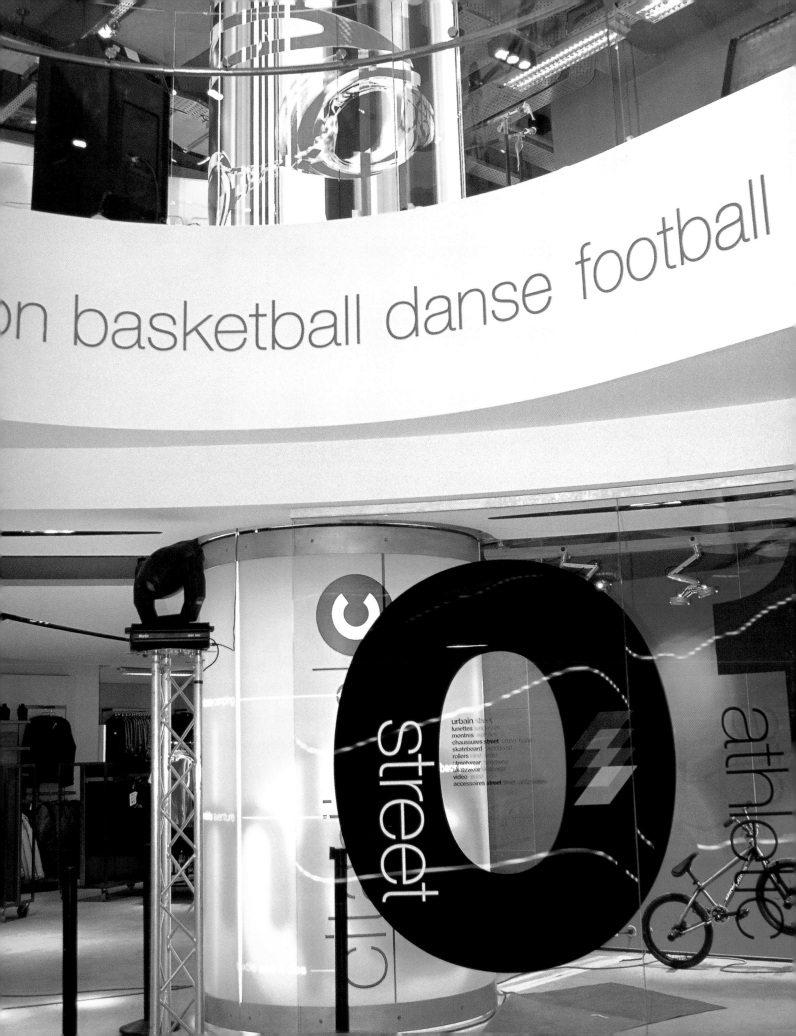

Big graphic panels identify individual departments **[3/4]**, such as running, football and outdoor, using oversize footwear images and simple department indicators. In addition, departments are identified by large images **[5/6]** which either form the backdrop to the department or wrap around the store's pillars. Given their size these images not only imbue the store with visual excitement but act as strong visual 'hooks', drawing consumers' attention and enabling them to locate the department they are after at a distance.

Graphics are also used in several other interesting ways. Brand availability is promoted using a simple but stylish gallery of footwear **[7]** with associated brand owners: Asics, Fila, New Balance et al. Sports as a passion and a lifestyle (the everyday reality of the muddy pitch and the battered but comfortable trainer) is conveyed by the beautifully photographed images of footwear **[8/9]**, clearly long out of their boxes. Illuminated pillar-mounted lightboxes feature digitally manipulated images **[10/11]** of sports items to capture the dynamism and flair of sports like football and tennis.

Research Studio's desire to create a store which was shocking but familiar, innovative and aggressive, pure and dynamic has resulted in an environment which is inspiring and attractive to its core target market of 15- to 50-year-olds.

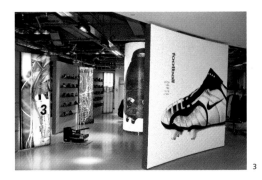

3

4

5

6

10

11

110

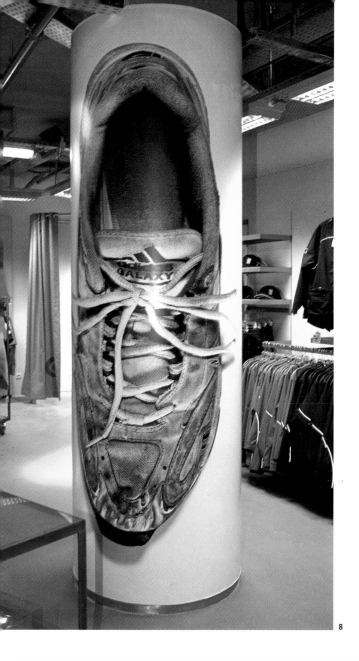

8

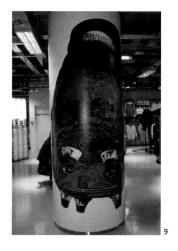

9

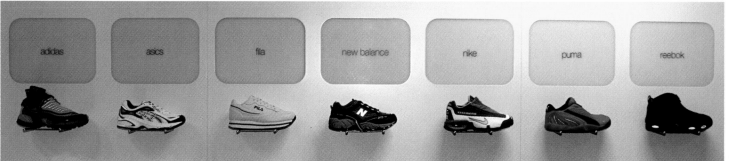

| adidas | asics | fila | new balance | nike | puma | reebok |

7

→

FAST FOOD

If London is anything to go by the world has gone fast-food mad. Coffee bars, hamburger joints, pizza parlours, soup and juice bars, bagel and noodle bars, sandwich shops – the list of fast-food choices is almost endless. On any given street you may find four coffee and three hamburger choices, let alone a few new concepts putting their first tentative toe in the water.

What distinguishes these companies? Take coffee bars as an example. It is hard to tell at first glance. They all seem to offer the same choice (filter, latte, cappuccino, espresso, etc.). Unless you are a true coffee aficionado you probably cannot tell any real difference between the coffee they serve, or that one brews coffee the purist's way and another uses a machine which makes the right noises but has been manufactured to cater for volume rather than quality.

Yet some people prefer one fast-food outlet over another. Sometimes this comes down to the product, sometimes it comes down to selection, or you may dislike the rather cumbersome process some of them employ to take your order and your money and then deliver your food to you. You may even prefer the choice of music they play or have a fetish for synthetic coloured uniforms.

Often it comes down to the environment and what this says about the values and personality of the brand. As the examples featured show, graphics can be used in very different ways to create a defining personality and build brand loyalty.

12

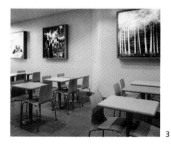

3

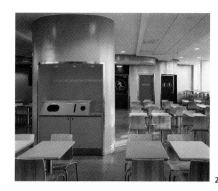

2

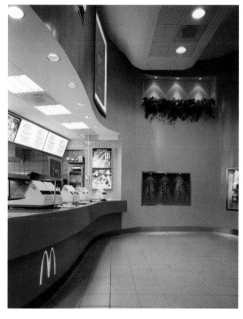

McDonald's

For those who find a typical McDonald's restaurant a brash, unsubtle experience their outlet in Gothenburg will be a refreshing change. Restraint, appealing design, modern forms and considered aesthetics are not ideas one would normally associate with the brand but they fit perfectly here.

Colours are used to define areas, such as the children's play and birthday party room, service areas like the waste disposal bays [1] and to highlight exits and utilities. A light grey is used as a contrast to accentuate the photographic displays and architectural features like the cubist staircase leading up to the second floor.

Vivid accent colours are also combined with over dimensionalised symbols, all using the circle motif [2], to help customers use and navigate their way around the restaurants. Much of their effectiveness derives from the simplicity of their use and the space around each.

Gothenburg has a strong tradition of photography and design and this is reflected in the restaurant. It serves as a gallery for the Photographic College of Gothenburg, showing work [3] of lecturers and students alike. This must be rewarding for them as it gives the pictures a much wider audience but it equally serves McDonald's well as it means the visual element of the interiors is constantly refreshed. Like symbols, the photographs achieve much of their impact, at a distance and close at hand, because they have room to breathe.

1

113

Client McDonald's
Design Ytterbornborn & Fuentes
Location Gothenburg, Sweden
Date 2000

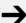

1

Vitesse

Vitesse, gourmet@speed, is a coffee and sandwich pit-stop in Sydney's business district, offering two blends of coffee and every possible combination of milk, soya milk, size and strength. One of the first things that strikes you about it is the very simple colour palette of white, brilliant orange and silver and the selectivity with which these are used. The outlet itself is a blizzard of white, a clean shell focusing one's attention on the strong branding, the staff in the uniforms of orange and the dynamic graphics behind the counter [1].

114

Client Vitesse
Design Landini Associates
Location Sydney, Australia
Date 1999

The branding, comprising fast-forward arrows and the gourmet@speed strapline, gains its impact from being instantly recognisable and from being the only ornamentation on packaging [2]. The orange, on the chairs and uniforms is suitably funky and fun, not surprising for a brand that says 'This shop is gas' in the doorway.

The graphics, which form a coffee combo flow-chart, simplify the complex selection process, helping customers firstly choose whether they want a hot or a cold drink and then helping them choose from a whole host of options. At one glance customers can see the breadth and the quality of the offer. The design uses peelable acrylic discs. This allows some of the information to be changed daily by the staff to promote different items such as the day's flavours, out of a potential menu of over 100. The design also incorporates two larger discs at each end where staff can write the daily special on to wipeable plastic inserts.

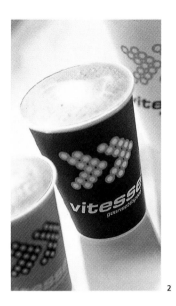

2

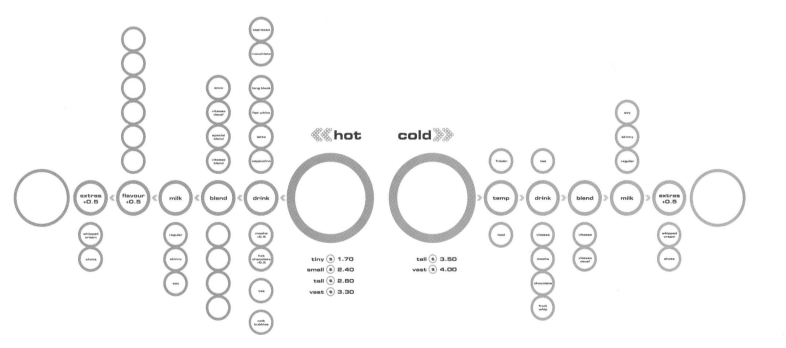

Soup Opera

In an article on the new phenomenon of soup bars in the weekend magazine supplement to the Independent newspaper the journalist quoted a customer as saying 'Soup Opera is worth going to if solely for the transparent bag with the 'S' logo in lightest turquoise. I'm keeping mine with my Joseph bags.' Given we, Lippa Pearce, had spent considerable time, working with Din Associates, creating a visual identity for Soup Opera which would position them at the premium end of the market we felt our approach had been vindicated. More recently Soup Opera was described by Harpers & Queen as 'soup couture'.

In contrast to Costa's very bold and very 'loud' graphics Soup Opera has a far more muted tone where the quality of the overall components is a major factor in its attractiveness to consumers. One of the biggest challenges Soup Opera faced was the British public's poor perceptions of soup, based on their normal diet of watery canned offerings and synthetic dried packet fare. So considerable effort was spent to ensure that the soups were the heroes. Menu boards emphasised the cosmopolitan nature of the recipes and the three carton sizes were named 'peckish', 'hungry' and 'famished' to lift the descriptions above the normal prosaic 'small', 'medium' and 'large'.

Strong branding is achieved through its selective use on core components like the window [1], carrier bags [2] and soup cartons. As with Costa, competition was a factor in the design solution. At the time Soup Opera launched they knew that at least two other companies were going to enter the market. To complement other elements of the brand's identity, such as the turquoise and maroon colour palette which is suggestive of the cold and hot soups on offer, a very distinctive, and differentiating, x-ray style of photography was chosen.

This has the double function of communicating that Soup Opera places great emphasis on the quality of their ingredients and the lack of artificial additives or preservatives. The x-rays say 'we have nothing to hide'. The images were used throughout their point-of-sale literature (such as their launch [3] and breakfast menu leaflets [4]) and in promotional posters where they were combined with witty word plays.

2

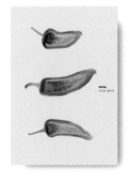

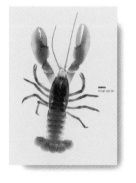

3

116

Client Soup Opera
Design Lippa Pearce and
Din Associates
Location London, UK
Date 1998

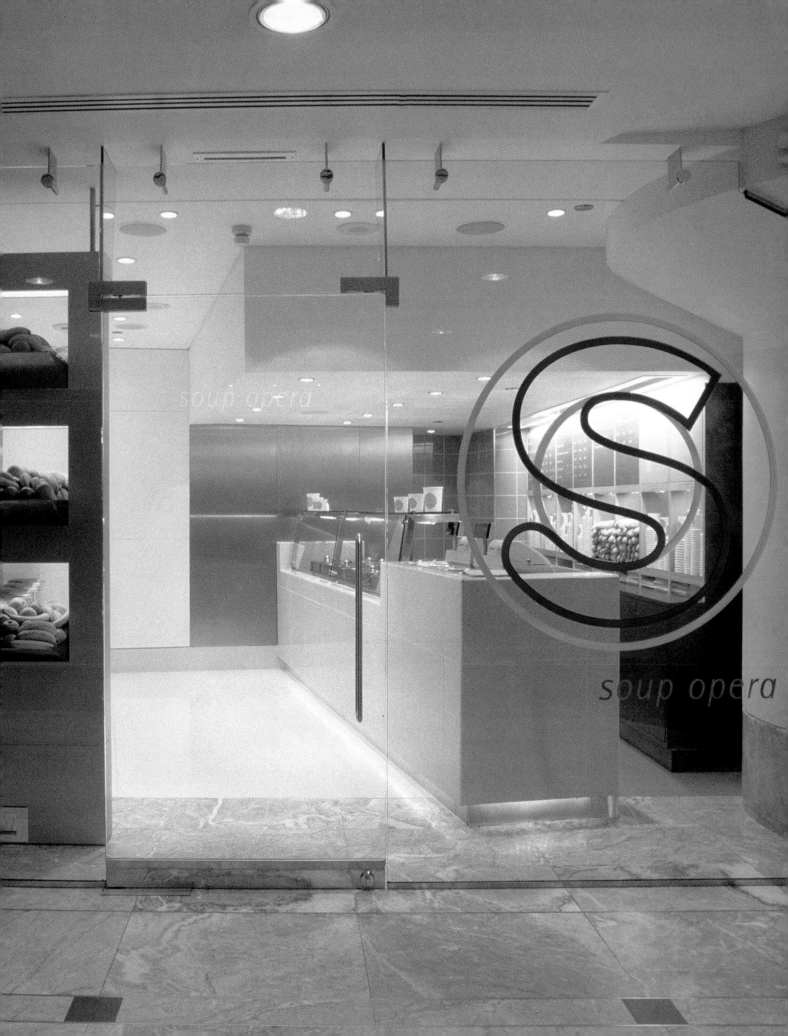

soup opera

Costa

In client presentations I've used Costa as a very good example of graphics being used to differentiate and give a brand a personality. In the UK Costa competes with other coffee bar chains like Starbucks, Coffee Republic, Aroma (now owned by McDonald's), Madisons and Cafe Nero and a huge plethora of independent coffee bars. In major cities like London they group together like doubledecker buses and can be found almost side by side on some streets.

To me the strength of Costa's visual approach, quite apart from its consistency across advertising [1], point of sale [2/3] and packaging [4/5/6], lies in its use of an idiosyncratic style of illustration with a boldness of form and colour. These things stand out and really draw the eye. They are also very different from the competitors' retail graphics.

It's not only the style and colours of the graphics but the wit being employed which makes them work well. Anyone who has stood in a coffee bar and looked at the menu knows the choice can be bewildering. With a line of people desperate for their caffeine fix we often fall back on the staples we know and order an espresso or cappuccino. Costa's approach educates less knowledgeable consumers while reinforcing the brand's Italian heritage – cuore d'Italia.

Client Costa
Design Mother
Location UK-wide
Date 2000

SUSHIWORLD

Sushi World

Sometimes designers have to make a virtue out of the constraints of a site. Sushi World occupies a small site in a shopping mall in Sydney. It is divided into back-of-house, hidden behind pivoting 'red banner' vertical menu boards, and front-of-house, divided into dry goods stacked in pigeon holes in shelving on the right-hand side and fresh produce in a refrigerated display on the left-hand side [1].

The whole of the red back wall [2] is devoted to the take-away menu and consists of a series of symbols representing the ingredients and varieties of sushi on offer. The simplicity and directness of this method of communicating choice suggests to me that Sushi World is targeting a wider audience than traditional sushi eaters, who will be knowledgeable about the product and more concerned with the quality of the ingredients. People trying the product for the first time will probably be looking for a more accessible way to trial the product and will therefore appreciate the more 'simplistic' language of the symbols.

The line between appearing authoritative/ expert/specialist and 'dumbing down' is a difficult one to tread. Ultimately it may well be determined by market economics, namely where the value is in the market, but getting the target market right is one of the issues designers need to understand if they are to get the visual language right.

SUSHI ORIGINATED IN JAPAN OVER 1000 YEARS AGO AS A WAY TO PRESERVE FISH

RAW FISH OR VEGETABLE ON VINEGARED RICE IS THE MOST COMMONLY KNOWN TYPE OF SUSHI

2

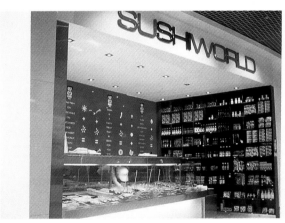

1

119

Client Sushi World
Design Landini Associates
Location Sydney, Australia
Date 1998

AUTOMOTIVE

The automotive world is hugely diverse: from dealers selling new cars to dodgy operators selling second-hand vehicles; from drivers whose passion for their cars is second only to that for their partners (and in some cases even greater), to drivers for whom a car is a necessary evil and as long as it goes see no reason to venture under its bonnet.

The diversity of cars and drivers results in a very broad range of retail options serving the needs of those looking to purchase a car and then keep it running. There are flashy dealers seducing prospective buyers with their gleaming showrooms and there are second-hand operators who struggle to achieve more than a string of multicoloured lights and a sad pot plant in the corner of their prefabricated offices. There are motor factors who pride themselves on the no frills, utilitarian nature of their shops (although calendars of big busted girls normally feature predominantly) to the big chains offering choice and an inspiring environment.

In this section we have selected case studies that represent three of these types: car dealer, second-hand operator and parts and accessories superstore. Each one shows the diversity in the marketplace and the diversity of graphic treatments being used. Two in particular turn normal expectations on their head.

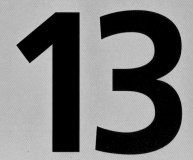

Halfords

Halfords, the auto and cycle accessory retailer, was founded over 100 years ago. It is now established as the UK's market leader with over 300 stores in a range of formats from high-street shops to superstores. Never one to rest on its laurels, the retailer undertook a series of new store format trials in 1999, one of which is Auto Depot (Auto Arcade on page 34 is another).

Collaborating with Ben Kelly Design we, Lippa Pearce, designed retail graphics which would take the warehouse retail concept common to DIY and adapt it to Halfords' core market. Our brief was to create a store which would be attractive to Halfords' existing target markets, such as general car maintainers and tourers, and new target markets like mechanical and accessory enthusiasts. In particular, Halfords was looking for a utilitarian approach, maximising the warehouse-shed format, and an approach which would communicate to the target markets the range and breadth of its offer.

The result was a holistic design solution in which every component of the retail format was considered. Starting in the car park telegraph pole-mounted signage **[1]** was employed to signal the different departments in the store. These then formed a line perpendicular to the store which continued right into the store until the main parts countered. Here the signage became directional, indicating the location of individual departments.

The exterior of the store **[2]** was painted using a combination of a bright attention-grabbing colour palatte, chevrons redolent of road markings and industrial-style arrows which were also then used to dramatic effect inside the building. For example, the arrows were used on the walls and floor as part of the wayfinding system **[3/4]**, and on the simple, numbered aisle signage **[5]** to indicate the location of individual products.

The chevrons were also painted on to purpose designed shelving corner guards to add to the colourful floorscape. They were used on the exterior of the building to indicate to customers the location of the two fitting bays **[6]** and on the floor of the interior of the building to locate the main parts desk and to provide customers with a highly visible orientation feature. Busy mechanics, for example, use the floor marking on repeat visits to find the parts desk speedily, collect their part, pay and exit the store.

Large lettering was also used to identify individual departments, such as the Fitting Bay **[7]**, or on windows **[8]** to promote the services on offer. In these cases, as with the shelving-mounted product signage and shelf-edge product information, the choice of gothic typeface supports the warehouse look.

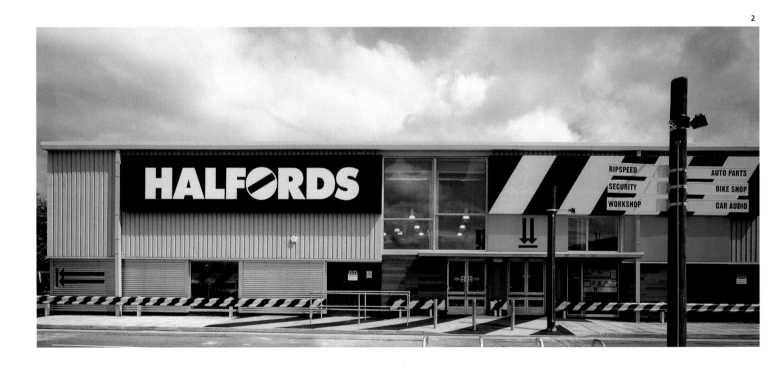

Retail Graphics
Automotive

Client Halfords Limited
Design Lippa Pearce &
Ben Kelly Design
Location Swansea, UK
Date 1999

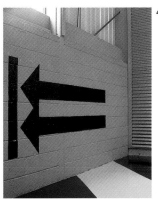

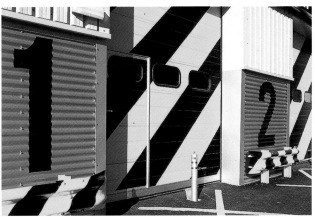

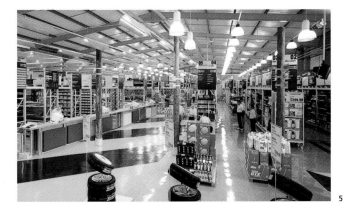

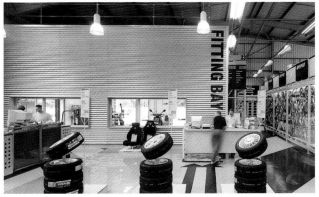

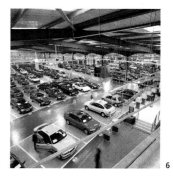

CarLand

In the UK, second-hand car sellers suffer, many would argue justifiably, from a very poor image. Despite this, UK sales of second-hand cars are estimated to be worth 23 billion pounds a year. Four million cars are sold by more than 6,000 franchised and a further 13,000 non-franchised smaller independent traders.

For years consumers had a very limited range of options for buying a second-hand car, motor dealer or car auction, but this is now changing. CarLand is founded on the application of retail principles to the used car market creating a customer friendly, motorshow-style, indoor superstore. Cars are displayed in the 100,000-square-foot site by category (people carriers, estates, small cars, saloons and hatchbacks, prestige, sports cars and four-wheel drives) and price (between £4,000 and £25,000).

Consumers can access the car of their choice through the CarLocator touch-screen system [1], and having selected their preference are provided with a print-out showing a digital photograph of the car, its features and specification, its insurance band, price and monthly repayment details – as well as a map indicating exactly where it is in the showroom.

CarLand is designed to be a family orientated destination rather than an overtly masculine environment. It features 'meeters and greeters' rather than salespeople and has a café, car accessory shop and even CartoonLand where children can enjoy cartoons and car-related Sega games while their parents look at the cars. In addition to these consumer friendly features CarLand's graphics play their part in creating an environment that is customer orientated.

The branding, employed on the front of the building [2], exterior monolithic signage [3], banners, reception and information desk [4] and CarLocators [5], deliberately uses the shape and style of car badges to provide reassurance that although this is a new concept it is not an alien one.

The colour palette of primary red, blue and yellow, deliberately chosen to appeal to both sexes and all ages, is used dynamically on the floors [6] to brighten a potentially drab, bare and cold environment. Outside it draws the eye both through its boldnesss and its application to the whole skin of the building. Inside the red and the blue are also used to demarcate the car-parking bays and enliven waiting areas, while the yellow provides a focus for the CarLocator touch-screens section.

124

Client CarLand
Design Rawls & Company
Location Lakeside, Thurrock, UK
Date 1999

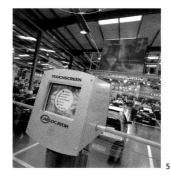

5

3

Customer communication takes different forms: Directional, such as the floor numbering which helps customers locate the car they are interested in and the information location signage; Sales orientated, such as the prominent message on the exterior of the building, and Reassuring, such as the messages regarding 150 point inspections by the RAC. Given that a 1997 Office of Fair Trading report said that problems arising from buying a used car were the most common cause of consumer complaint recorded by local authorities these reassuring messages assume a greater significance.

To my mind what makes the graphics successful in this instance is their individualistic treatment – the trolleyed sales banners **[7]** are a great touch – and the consistent application of CarLand's visual identity across all of the elements.

7

4

Toyota

Toyota's showroom is interesting because of the way it combines different types of graphics to engage with consumers and encourage them to interact with the cars, open doors, sit inside and read more about each model.

The showroom signage and graphics do more than merely direct. They inspire and invite. The environment is visually stimulating and the language reflects this. Calls to action such as 'climb in' and 'try me' are positioned according to type of model.

Scene setters, such as the wrap-around visual backgrounds **[1]**, focus attention on each model, celebrating their style and highlighting main features. The objective here is to create both a rational and an emotional context for each car and hopefully inspire prospective buyers.

Retail Graphics
Automotive

Client Toyota
Design Design House
Location Bristol, UK
Date 2000

3 4 5

This desire to respond to consumers' rational and emotional decision-making triggers is reflected in the different devices used and the way they are used. Emotional triggers are targeted through imagery [2] and large-scale messages. Rational triggers are provided for by more in-depth, systematic information devices.

Floor graphics for the four-wheel-drive models [3] wittily employ the visual language of topographic maps to convey performance, while the display panels [4] for colour selection, neatly integrate the printed brochures and thus provide prospective buyers with greater levels of information when they are further down the decision-making process.

As a sign of the times the showrooms also mix traditional media such as the posters extolling corporate values, with new media, such as the PCs offering internet access to more information [5]. The PCs also work on a subliminal level as they indicate to consumers that they are welcome to linger and take their time without fear of being jumped on by an oleaginous salesperson.

→

HOME FURNISHINGS

Turn on the TV, visit any newsagents, sit in your doctor's or dentist's waiting room and you are bound to find a programme or magazine about interior decor and soft furnishings. Looking after your homes and surrounding yourself with beautiful furnishings seems to be a national, if not international, obsession. You can surf the web and find just the chair you are looking for. You can order a new sofa from a mail-order catalogue or you can visit a specialist or department store and be seduced into taking out a credit deal because you cannot live without that Philippe Starck bathroom set or that leather sofa.

Saloni and Macy's Home Store illustrate two different types of retailer catering to consumers' desires. Although different they both demonstrate how the retail environment functions in this sector of the market as a purveyor of goods and an inspiration to consumers. Selection is everything but illustrating the latest look and the latest colours, exploiting the artful arrangement of primary and secondary pieces and using graphics to suggest lifestyle and mood are all features retailers employ to make consumers enter their stores with one intention and come out with more than they intended.

14

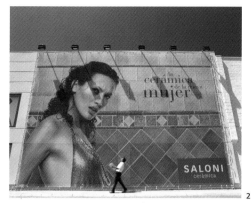

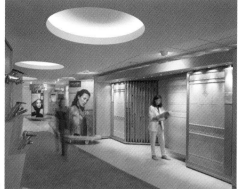

Saloni

Before Landor rebranded the stores, Saloni was known as Keops in Spain and Portugal. Their stores employed a design and trading format very similar to the competition and together with a very dated brand identity the stores lacked any strong differentiating features in a very competitive marketplace. In addition, the brand was failing to capitalise on the company's considerable heritage or benefit from its professional manufacturing status in any of its stores.

The key target audience – the 'Saloni Woman' – is young, independent, female professionals in the 25 to 35 age group and the challenge was to create an environment which would be attractive and inspiring to them. The solution is a good illustration of the need to address all exterior and interior aspects of the retail proposition when trying to realign consumers' perceptions of a brand.

As Saloni Ceramica the brand is strengthened and focused. The exterior not only signals this change with the red buttress pillar [1] focusing the eye on the new branding but it draws attention with its full-height poster [2] making the most of the building as a canvas. Such a radical change to the exterior communicates volumes to consumers because it invites them to reappraise the brand.

Inside, the target market finds itself reflected in the large displays – a theme begun on the outside in the large picture windows. The confident stock display highlights the choice on offer (particularly the breadth and depth of products) while the graphics juxtapose lifestyle imagery with women clearly at home with their choice – a choice expressive of their individualist taste.

Interestingly Saloni and CarLand (see page 124) both use wheeled displays [3] to give them maximum flexibility of message and position, and both have used these devices to reinforce the brand.

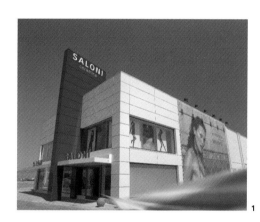

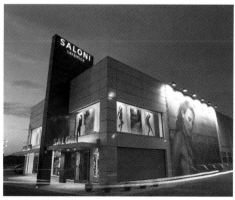

Client Saloni
Design Landor Associates
Location Spain and Portugal-wide
Date 2001

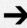

Macy's Home Store

Macy's Home Store in South Coast Plaza, California, occupies 213,700 square feet on three floors. It is a department store dedicated to the home. The first floor showcases Housewares, the second Dining and Living and the third floor houses Bed and Bath. The challenge facing Macy's was that in Orange County they were not known for furniture so if they were going to make a mark they would have to do something different from the competition.

The store is arranged into parent departments with satellite sections. For example, a parent area for decorative home items including china, silver and crystal appears on the second floor, while a satellite area is found in the furniture department, near dining-room tables, making it easier for customers to match place settings with the dining-room furniture. In addition, particular designers' collections are displayed together.

The role of graphics is threefold: to communicate externally that Macy's Home Store has something new to offer; to inspire and excite shoppers and to help visitors navigate the store.

Starting with the outside Macy's decided to communicate to consumers that this was a new concept in home furnishings, and a different type of Macy's, by changing their normally white logo to a vibrant cerulean blue and by making the Macy's logo secondary to the 'Home' logo. They then punched a hole in the front of the building's facade and placed a wall of windows on the second and third floors. These windows [1] are about 25 to 30 feet per bay. Behind the glass changeable graphics are placed, using images in a style rendolent of Ansel Adams' photographs – almost of an art quality.

There is a ring road that goes around the mall in which the store is located, so passing drivers look right at the building and the whole of the front of the store acts as a huge, dramatic billboard particularly at night.

Inside, the large-scale images are used as part of each department's merchandising [2] and as part of the wayfinding system. This system employs a different colour for each floor at the escalator well and on the main columns in the spine of the building to indicate the departments on each floor. Because of the scale of the photographs they not only add drama to the environment, accentuated by the fact they appear against a white background, but they draw customers up the building [3]. Added to this the images are coupled with quotations and proverbs designed to appeal to the consumers' emotions.

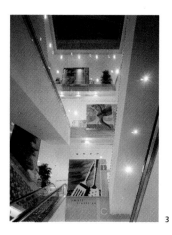

3

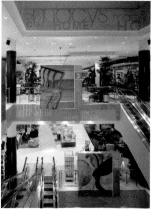

2

Client Macy's Home Store
Design FRCH
Location Costa Mesa, USA
Date 2001

→

OPTICIANS

In the bad old days if you needed glasses your options were severely limited. Those with very bad eyesight ended up wearing thick, eye distorting lenses and knew the truth of Dorothy Parker's quip 'men never make passes at girls who wear glasses'. Now the choice is huge and glasses have become a fashion item spawning frame designs from all of the big-name designers.

And it is not just glasses. Now there is also a choice of contact lenses and even these have changed radically so that you can now buy disposable lenses and even coloured lenses. The British hurdler Colin Jackson wore Union Jack patterned lens at an international running event in 1997.

Coupled with the choice available the service has changed. Before, you had to wait days for your new eyewear prescription. Now you can wait a few hours at most while your glasses are prepared in a hi-tech, in-store optical 'laboratory'.

Such are the developments in the whole optical area that it is even possible to visit high-street retailers to have laser treatment for the correction of eye defects. In the UK one retailer, Boots, offers both an optician and a laser-eye treatment service, and the two case studies show how they have used graphics to achieve different ends.

15

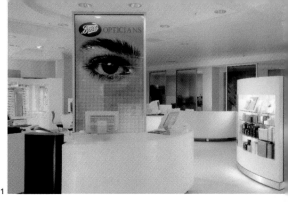

`1`

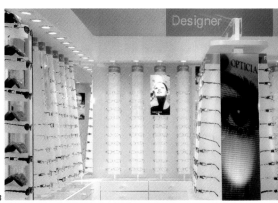

`2`

`3`

Boots Opticians

Boots have both stand-alone shops and optician departments. Our case study shows one of their in-store departments. Because the opticians' department's look must work within the look of the overall store the graphics work within Boots' environmental design parameters – perhaps the most noticeable features being its use of white and a clean, uncluttered style.

Within this context there are three types of graphics. The first is the use of large-scale images all associated with the eye. The desire on the part of the designers, Fern Green, was to create an image that would anchor the department in the store while acting as a beacon [1]. Shoppers looking across the store will see it and recognise its significance. The images are all full height and are an integral part of the glass screens. Each, the eye as their cue, communicate some aspect of the department's offer, for example: Eye Test [2], and Contact Lenses.

The second type of graphic is the use of simple informational signage indicating the range on offer: Men's, Women's, the Boots Collection, the Designer Collection (the brand names stocked), Sunglasses and Oval, Rectangular and Round glasses. This information sits either on the bulkheads or tops each of the stacks of glasses. In some cases this simple indicative signage is joined by showcards promoting a particular brand [3].

The last type of graphics is the provision of information leaflets on different ranges of glasses, helping customers understand and choose the best option for themselves.

133

Client Boots Opticians
Design Fern Green Partnership & Karen Wilks
Location Kingston, UK
Date 2000

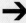

Boots Laser Clinic

What is conspicuous about Boots Laser Clinic is the stark contrast between the simple, uncluttered look of the clinic, with its preponderance of white walls, and the bold, colourful and arresting imagery which forms a frieze around the walls.

The restraint and cleanliness of the white communicates clinical efficiency and expertise but it also creates an environment which could seem cold and alien. Having laser-eye treatment must cause people concern and while the staff play a major part in providing reassurance and the comfort of an understanding professional the images also play a role in softening the environment.

The images, all backlit to give the colours punch, cover the full spectrum of colours from cold blues through to warm reds. These colours are broken up into vertical lines, to suggest the laser scanning process, and are interspersed with 'abstract' images, which take their inspiration from science. The frieze acts as a balance to the technology, which is a necessary part of the clinic. Like the images dentists sometimes hang above their chairs they work as a 'soother', like mellow music. In this case the abstraction of the natural elements invites investigation, and takes the mind away from its concerns. To my mind they are also a wonderful celebration of the fit eye's ability to see and identify the full spectrum of colours and thus suggest the end result the visitor will enjoy.

134

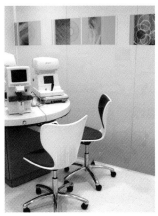

Client Boots Opticians
Design Fern Green Partnership & Karen Wilks
Location London, UK
Date 2001

HEALTHCARE

In many countries chemists and health stores play a significant role in the health of the nation. While other professions have seen a dilution in their social status, pharmacists still continue to hold our respect. We trust their word and seek their advice. The pharmacist in a white coat is a potent symbol of trust and authority.

We also seek the advice of health-store staff more often than we ask the advice of other shop staff. Often this is because the people who run these stores are 'champions' of alternative therapies and act as gatekeepers to the subject. Just as often it's because we find these stores confusing to shop, filled as they are with strange-sounding products like Gingko Biloba and Echinacea.

What is interesting in recent years is the increased acceptance by modern consumers of complementary medicines and beauty treatments and this has led to mainstream chemists stocking these remedies. It has also led to retailers of natural solutions developing increasingly sophisticated offers to attract a wider consumer base.

As our three case studies illustrate there are generic issues all address, such as the communication of trust and efficacy, and unique issues specific to each, such as education and accessibility. What their graphic treatments also show is the role of graphic communication as a differentiator.

16

FARMACIA
urban healing

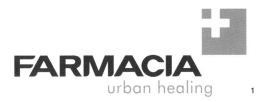

1

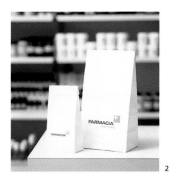

2

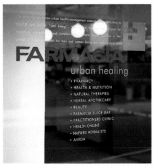

3

Farmacia

Farmacia is a new urban health management concept totally dedicated to physical and mental 'well being'. It services the growing demand for innovative healthcare solutions, whether these be conventional or complementary natural solutions. It is targeted at both men and women living and working in a city, where their lifestyle and pace of life makes demands on them.

What is interesting about Farmacia is the way it bridges both conventional and 'alternative' medicine because this presents a challenge in the way it positions itself. In the UK at least there has long been a distinction between the traditional pharmacies offering allopathic treatments and the natural health stores and this distinction is usually very clear from the look and feel of each.

In attempting to provide a holistic solution, offering the best of both worlds, Farmacia could have failed by creating a visual look which was attractive to neither camp, while at the same time being unattractive to the new camp of consumers looking for the best of both worlds.

Interestingly, the visual solution borrows from both, although at first it appears to borrow more from the traditional pharmacy. The identity [1] is clean, confident and modern, while the colour palette of white and pale blue has a clinical and authoritative feel about it. Moreover the identity is calm and understated – the pharmacy bags [2] derive their authority from the simple application of the logotype and symbol.

Where Farmacia 'borrows' from natural-health stores is in its language (for example, its description on the window 'urban healing') [3] and the selection of own-brand packaging [4] (for example, the jars of herbs in the apothecary).

Overall the application of graphics throughout the chemist is restrained, focusing on providing customers with the information they need to find the right product [5], understand the range of services available and feel confident about trying some of the alternative therapies on offer.

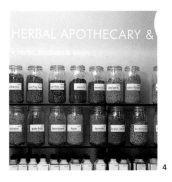

4

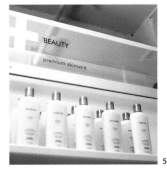

5

137

Client Farmacia
Design Egan Melia
Location London, UK
Date 1998

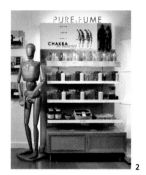

Aveda

The natural health and beauty treatments market is a fascinating one. In India, South America and Asia plants and flowers have been at the heart of their health and beauty regimes for centuries but in the West we have been slow in the past to realise their benefits. Brands like Aveda are changing all that. Their blend of the natural and the scientific in irresistible 'packaging' (both retail and product) is attracting more and more consumers.

For many, Aveda is a brand with cachet, whose philosophy of 'the art and science of pure flower and plant essences' is right on the button. One key to Aveda's success is their eschewing of any of the typical trappings of natural treatments (the open-toed sandal brigade comes to mind) and their adoption of the sophisticated look and feel of the cosmetics house. A usual corollary of this look is the simple and stylish retail environment and the store [1] illustrated epitomises this.

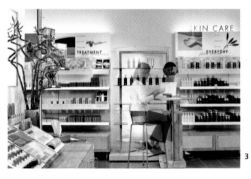

The windows are deliberately clear of product to give an unobscured view inside. The products and the displays are left to tempt passers-by in. Where graphics are used in the windows they support the brand proposition.

Because the stores are so uncluttered they make the product displays [2/3] assume a prominence, as do the white walls. A sophisticated information architecture has been developed to educate customers about the aspirational aspects of the brand, as well as provide in-depth information and individual product highlights. At a top-shelf level [4] they tell consumers what section they are looking at (for example, Perfume, Shampoos and Skincare). At the next level down they convey the properties of the treatments (for example, Everyday Plant Actives: vital, healthy, fresh). The top-shelf level of the display uses beautiful images of flowers and plants to reinforce the brand's essence and the individual shelves contain product information to enable shoppers to select the right product. In effect, a marriage of inspiration, promotion and navigation.

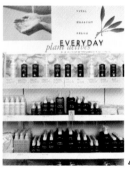

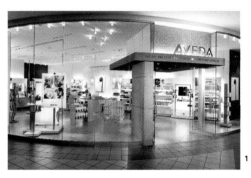

Retail Graphics
Healthcare

Client Aveda
Design Gensler
Location Edina, USA
Date 1999

Lund Osler

In its promotional brochure Lund Osler expresses its belief in total dental care and the promotion of 'More Prevention…Less Intervention'. The dental practice offers every client 'a relationship based on openness, trust, understanding' and the provision of complete freedom of choice. To support its belief in preventative dentistry and create a surgery where impersonal service and a forbidding atmosphere is banished, Lund Osler use graphics in a number of ways to complement the architecture of Powell Tuck Associates.

The entrance [1] is fresh, inviting and individualistic, an effect achieved by the combination of 'transparent' architecture, a clinical but soothing colour palette of white with accent colours and an absence of normal dentist's paraphernalia. In addition, two walls [2] feature signwritten text which attracts the attention of passers-by and encourages them to think about their dental health and the need to make regular visits to the dentist. The walls' message supports the surgery's tagline of dental healthcare.

The dental practice believes that reassurance comes through knowledge and choice. Accordingly, it places great emphasis on one-to-one communication between the dentist and patient and the use of advanced technology as part of their consultation, diagnosis and treatment process. In keeping with this attitude, the practice's brochure combines text and images in a fresh way to help people understand dental problems and treatment, as well as Lund Osler's own approach to dental healthcare [3/4]. The overall effect is reassurance through enlightenment for the surgery visitor and a distinctive personality for Lund Osler.

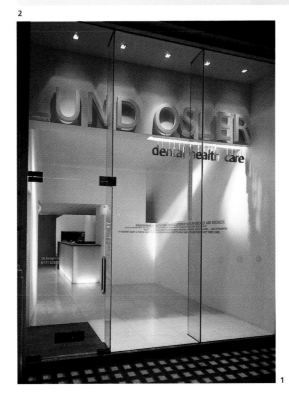

Client Lund Osler
Designer Studio Myerscough
Location London, UK
Date 1998

CHILDREN'S

Recently Gap ran a TV advertising campaign based on a troupe of dancers, wearing their new season's clothes, dancing to different styles of music. The adverts were distinctive because of their use of music and dance, a graphic illustration of a brand defining and differentiating itself by its use of sound and imagery. They were also interesting because my five-year-old son was able to identify the brand within a number of seconds and well before Gap's blue and white logotype appeared.

This brand awareness is a modern phenomenon, and one which retailers increasingly have to be aware of with certain segments of the children's market. Moreover, retailers have to understand the relationship between purchaser (parent) and chooser (child), and the different triggers which affect their selection process.

In some cases, such as Stride Rite, the parent plays a major role in the decision-making process and will overrule a child if they think one purchase is better for the child than another. In others, such as Velvet Pixies, the parent often sits back with a bemused look on their face as their offspring chooses based on a developing personal taste or a group consensus of what is 'in' and what is 'out'.

For designers it is equally important to understand how graphics can be relevant and meaningful to the different groups. Get it right and you strike a motivating chord. Get it wrong and your young critics will show no hesitation in letting you know while parents will seek a brand more sympathetic to their needs.

17

Early Learning Centre

Early Learning Centre (ELC) has been a feature of British high streets for a number of years; their range of toys and games a godsend for parents looking to develop their children's skills and capabilities. Like all brands they understand the need to be responsive to a changing world and Checkland Kindleysides' work with the retailer focused on ensuring the brand remained dynamic and relevant. They were tasked by ELC to redefine the brand's values and image, making 'magical learning' (that moment when a child's eyes light up having learnt through play) the heart of the brand.

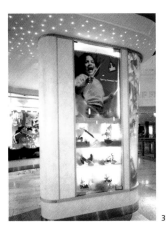

3

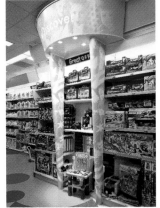

1

The retailer's core product categories were restructured into the way children play and learn from ELC toys. Six strong, colour-coded product categories were defined – Early Years, Imagine, Discover, Art and Crafts, Brain Power, Sport and Activity – and used in both the store as part of its navigation system and the retailer's product segmentation in their catalogue. Store zones **[1]** were defined through high-level colour-coded signage, shelf edgers, gondola headers and focus pods featuring product and magical learning imagery.

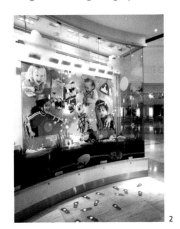

2

At the flagship store at Bluewater this category zoning was accompanied by an arcaded entrance **[2/3]** with twinkling overhead lights, large magical learning images and interactive coloured footpads and lights where a child can interact with the display in the feature windows. A main feature of the entrance is a central-island window display which incorporates child-level surprise views through frosted glass to the products hidden behind.

Devices in-store, like the low-level interactive area at the till, illustrate how both retailer and designers have been cognisant of both the children and parents in the store and graphics design. They entertain children while parents are otherwise engaged. Given the way children, within ELC's core target groups, respond to and interact with imagery the graphic element of the total solution plays a very strong role.

Client Early Learning Centre
Design Checkland Kindleysides
Location Bluewater, Kent, UK
Date 1999

→

Stride Rite

Stride Rite is one of America's favourite brands of children's shoes. Its stores are shopped by well educated, socially minded young mums looking for value and selection. Their children's well being, value, fashion, and the children's opinions, are all factors in their decision-making process. Like all mums they are looking for a shopping environment which is going to make their visit easier.

Anyone with young children will know that shopping with them, and for them, can be one of the most frustrating and potentially stressful activities going. They get tired and emotional. They get distracted and boisterous. Their mood can turn in the blink of an eye and before one knows it the pair of shoes they loved a moment before they now cannot wait to get off their feet.

Creating the right environment therefore demands that the designer be cognisant of the primary target market, mums, but also be receptive to the way children behave and respond to stimuli, and thus create a store they will find pleasure in. Selbert Perkins' work on the graphic elements of Stride Rite' stores demonstrates that they know their target audience well.

As part of their design work they refocused the brand imagery around 'the joy of growing up'. Their bright, new logo [1] with playful faces, reflecting gender equality and multi-culturalism creates a welcome portal [2] to the store in a style which is appealing to both adults and children. It also gives them a motif to extend to the store walls and block display units, where its oversize application in a rich primary colour palette engages children's attention and creates a happy, fun environment.

The integration of emotive photography into the displays [3] subtly 'exploits' young mums' strong emotional relationships with their children, for few can resist the 'aaghh' factor in the quality black-and-white photography, but it also communicates the age ranges covered by the brand.

In-store signage also contributes to making a store visit easier and more productive. The hanging, 'springed' signage [4], which is guaranteed to make both adult and child smile, segments the store into age groups. For young mums, tired and frazzled by their young charges, being able to navigate the store quickly is a godsend.

Lastly, literature [5] available in-store communicates the brand's 'joy of growing up' philosophy, providing substantiation of the brand's values and product line-up, including recent rationalisation of the previously confusing disparate sub-brands.

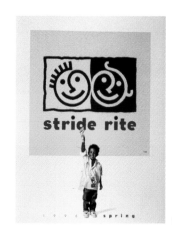

1

142

Client Stride Rite
Design Selbert Perkins
Location Lexington, USA
Date 1995

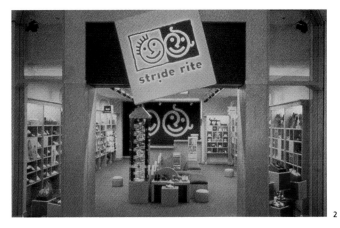

2

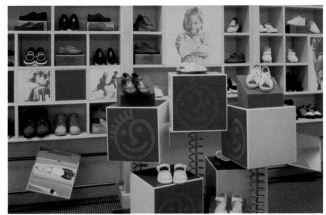

3

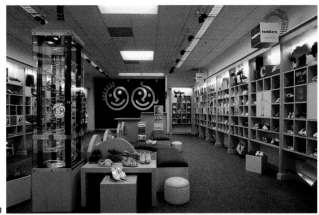

4

5

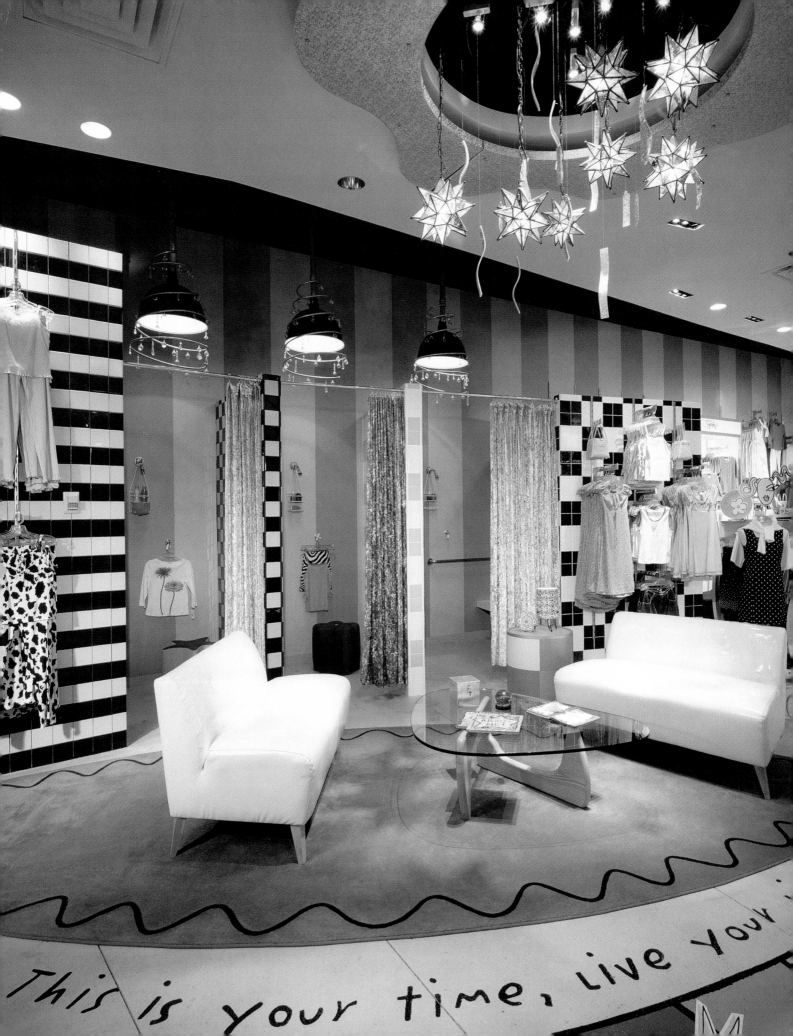

This is your time, live your

Velvet Pixies

Velvet Pixies is a trend-driven, fantasy-based store featuring private label apparel, accessories and lifestyle 'gear' targeted at girls aged 7 to 12. The target group, defined by FRCH and Claire's management, is urban and urbane young girls with spending power. Attributes such as progressive, energetic, sincere, flirtatious, adventurous, fun-loving, unconventional, responsive, artful, cool, feminine, headstrong and unique make for a heady mix. The stores, conceived as a lifestyle and fashion club, are designed to be attractive to this notoriously difficult-to-please target group.

In fact, Velvet Pixies' positioning statement can literally be found hand-painted along the 'Pixie Path', the store's main traffic aisle **[1/2]**. Using a youthful printed style of handwriting the look and tone of the words are meant to look like a diary entry. The full text is also rendered on digitally printed wallpaper wrapped on structural columns.

Appealing to the girls' sense of fashion, the overall colour and materials palette ranges from pinks and purples designated for wall paint and wallpaper to greens and yellows found on fixturing. Indeed the palette is so resolutely 'young girl' that it is guaranteed to signal from the store fascia **[3]** that this store is for them and no-one else, thus cementing the club feel.

This palette was accompanied by a graphic 'voice', to use FRCH's term, by creating an icon system featuring the 'Pixie Girls' which can be found with vinyl graphics overlaid on the main traffic aisle as mannequin toppers, on walls **[4]** and on the front windows.

In addition, lifestyle graphics featuring young girls in the store's clothes are also used throughout the store. A series of butterflies, hearts, stars and flowers can be found on stickers, gift bags and shopping bags. Hat boxes, custom sign holders, 'fashion tip' cards, and price and promotion cards complete the graphics package.

Overall what is significant about the graphic treatment in Velvet Pixies is its busyness. Visual stimulation is everywhere. Walk into any young girl's bedroom and you will find exactly the same thing. Where FRCH has been successful is in creating an artificial environment which looks the opposite to the target market. Instead, they feel it belongs to them – a place they can hang out with their friends, try on clothes, put on make-up and 'grab a bite' at the Poodle Bar.

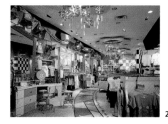

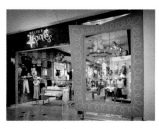

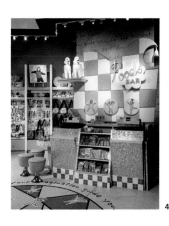

Client Claire's Stores Inc.
Design FRCH
Location Rockaway, USA
Date 1999

WATCHES

The watch world is characterised by choice. Every taste is catered for. Every price point offered. The treasured item has been joined by the throwaway. When it breaks don't fix it, buy another one. The classic timepiece worn every day has now become a fashion item changed to match one's outfit. Watches have become status symbols, engendering a huge counterfeit trade. Task-specific timepieces, such as diver's watches, have 'crossed over' to the mainstream and are worn as symbols of rugged sportsmanship.

Given the choice consumers have, brand owners are responding in new and innovative ways to capture the attention of potential customers, and reinforce existing owners' perceptions of their brands. As two of the projects featured show, brand owners are using the retail environment to not only sell their products but provide customers with a brand experience. They are doing this to engender identification with the brand's values and personality and encourage on-going loyalty.

Retailers in turn, like Watch2Watch, are reinventing the norm to make buying a watch a more enjoyable experience, removing some of the barriers that have traditionally existed and thinking about how consumers select the watch they want and try it on.

18

Watch2Watch

The primary objective behind the design of Watch2Watch's shop was to rethink watch retailing. Traditionally watches are displayed in shop windows behind glass and then in cabinets and display cases in-store. To try a watch on normally involves the assistance of the store staff.

Watch2Watch wanted to remove the barrier between the customer and the product. Their acrylic security watch holders, their watch 'bananas', allow customers to try on any product at their own convenience. In one move bulk display cases are dispensed with and the store becomes a gallery for the watches incorporating two eye-catching pods [1] of watches suspended from the ceiling.

Given the minimalism of the display fixtures, the triumph of Cobalt's graphics for Watch2Watch is their restraint. The graphics serve the customer's needs without being obtrusive. 'Bus stop' brand signs [2] set perpendicular to the walls and running along the tops of the displays help customers find preferred brands and communicate brand range. These brand indicators also run around the top of the pods.

A graphic panel, with three illustrations, tells customers how to use the watch bananas, and one of these is featured at the top of each display, set flush to the wall.

Behind the till a large-format display, in accent maroon, is far more tongue-in-cheek. Featuring quirky facts about time – for example, how long it takes to make a perfect martini or field strip an M16 carbine – this display is updated depending on seasonal sales. And lastly, in the same spirit of playfulness the name of the retailer is spelt out in three international symbols [3].

3

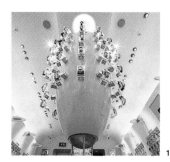

1

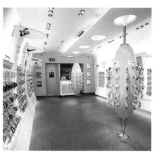

2

3

147

Client Watch2Watch
Design Cobalt
Location London, UK
Date 1998

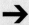

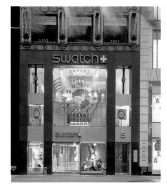
2

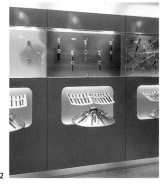
3

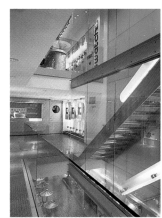

Swatch

Swatch's store on 57th Street in New York is their 5,000-square-foot flagship. Like a Swatch watch, the store is machinery with personality – a fitting description of the watches themselves. A glass vacuum, or pneumatic tube system [1], through which Swatch's watches are displayed and delivered throughout the store interconnects the three distinctive floors of the Swatch Timeship, which are an amalgam of transparent and reflective materials, changing projected images, and video and lighting installations.

Dominating the storefront [2] is a mammoth Swatch model GK209 ('Jelly'), a giant watch three metres in diameter, which has become the landmark timekeeper of 57th Street. This watch, in conjunction with bold branding and use of the windows on the second and third floors to promote oversize Swatch models, makes the whole of the exterior of the building a dramatic brand statement.

Inside, the whole environment is an intriguing collaboration of architecture, displays, materials and innovative space usage. The gaps between treads on the ground-floor staircase is used as a projection surface so that enormous, illuminated, constantly changing images of Swatch inspirations are visible from the street. As visitors climb upstairs to the mezzanine level, they are accompanied by these images and overtaken by actual Swatches moving up and down inside the clear pneumatic tubes.

As a brand, Swatch is synonymous with the use of different types of materials and colours in its watches and it's not surprising to find colour used so dramatically throughout the building. On the ground floor the terrazzo floor is dyed blue (the colour of time) while on other floors different colours are used to accent displays [3].

More recently Swatch has used innovative display materials [4], called contra vision, in a promotional campaign for their range of Skin watches. The movement of the changing image, not to mention the image itself, catches the eye and draws your attention. This sort of engaging display media, with its playfulness and fun, is in keeping with the brand itself and strongly attuned to Swatch's young-in-body-as-well-as-mind target market.

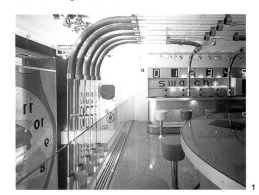
1

Client Swatch
Design Pentagram
Location New York, USA
Date 1996

Retail Graphics
Watches

4

Client Swatch
Design Taylor McKenzie
Location London, UK
Date 2000

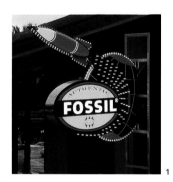

1

Fossil

If the words minimalism and restraint spring to mind when looking at Watch2Watch the opposite must be true of Fossil. Both their Orlando and Columbus stores are a riot of colour, imagery and logos – all used to represent the essence of the brand, while emphasising the hip, nostalgic image shoppers have come to recognise as uniquely 'Fossil'.

The stores are a cornucopia of graphic treatments: attention grabbing, oversized rocket-ship signs **[1]**, reminiscent of pylon signs of the Sputnik age; large posters trimmed with chasing lights highlighting feature products; drive-in movie screens showing a video montage of vintage television shows, classic ads and Fossil messages; nostalgic icons from Fossil's vast archive of brand art; a canopied watch showcase **[2]** flaunting oversized illuminated F-O-S-S-I-L letters anchors the store at its centre and recalls service stations of the Fifties; signature Fifties-style petrol pumps accentuate the retro feel; painted murals of Fifties American life **[3]**, show cards and display headers.

The style of Fossil's stores is not to everyone's taste just as the retro look isn't, but that in a way is its strength. By being unabashedly proud of the nostalgic, the kitsch even, the brand is distinctive and strong. Buy a Fossil watch and the packaging and literature you receive with it is all part of the deal. The stores say exactly the same thing. No Swiss restraint or Asian functionalism here. Instead, you get more and

then some. The mistake Fossil certainly has not made is in allowing the graphics to obscure the product. Fossil is retro but it is fresh, updated retro. The products are all displayed to maximum effect, with clear demarcation between watches, sunglasses **[4]**, and custom cases.

In their own way Swatch's Timeship and these Fossil stores achieve the same thing – they help define the brand. By visiting the stores you experience the brand. Whereas Swatch achieved this through the integration of architecture, delivery, materials and colours into the whole store concept so that they became one and the same, Fossil achieve this by the layering of devices on top of the store's shell, just as the brand's personality is layered on top of the product.

2

Client Fossil
Design Jon Greenberg & Associates
Location Columbus and Orlando, USA
Date 1997

Retail Graphics
Watches

3

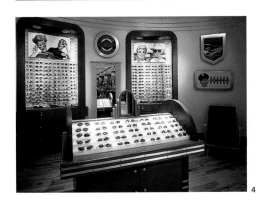

4

→

PERSONAL CARE

Looking after oneself is hardly a new phenomenon. Any study of social history illustrates an international obsession with the way we look. Whether it's a preoccupation with the body, face, hair or nails this narcissistic tendency, which manifests itself in all of us to differing degrees, is catered to by a wealth of retailers – from large department stores to hairdressers and beauty salons. Many of these retailers employ an almost universal language dominated by glamour and aspiration and accompanied by the ever attentive white-clad consultant with her immaculate make-up, or body-pierced stylist.

An interesting trend in recent years has been the appearance of niche operators providing a highly focused and specialist service, as illustrated by Ten Nail Bar, and the reappraisal of the traditional formats such as men's barbers, graphically illustrated by the featured Lynx Barbers.

Both in their way are reactions to more demanding consumers, whether they are more demanding in how they spend their much-valued free time or more demanding about their service expectations given the amount of disposable income they are prepared to devote to looking after their looks.

19

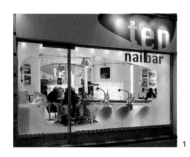

1

2

5

Ten Nail Bar

Ten is interesting for a diverse number of reasons. Although nail bars are a regular part of American women's beauty regimes, over 70 per cent of women in the UK have never had a manicure.

An implicit part of the brief was to make Ten attractive to women whose preconceptions about nail bars were governed by the notion that they were only for 'ladies who lunch'. This meant that Ten's visual 'language' would play an important part in overturning these preconceptions. In addition, the owners were ambitious to build Ten into a strong mass-market brand which would support a chain of high-street nail bars. This meant the nail bars needed to have a strong street presence, sometimes referred to as 'shout' and they needed to signal to consumers that the environment was friendly, sociable and attractive – far removed from the rather intimidating, discreet aesthetic of traditional beauty salons.

The success of Ten lies in the marriage of two things. First, Studio Haggar has created an environment which cannot fail to be attractive with its modern look, bright lighting and distinctive nail bar feature. The distinctive

window [1] with its iconic fingernail reveal draws the eye of passers-by. Combined with the Ten branding on the fascia it also acts as a 'flag' – an important element in retail street presence. Consumers familiar with the brand will store the shape in their minds and as they travel around and see more of them will ascribe more and more authority to the brand. Given that two other nail bar offers were launched in the same month as Ten, elements like these, which give the brand prominence, assume an increasing importance.

Second, Ten uses imagery and language in its graphics to differentiate itself from the competition. From the service menu using the vocabulary of cocktails, such as French Kiss, Colour Me Crazy and Armed and Dangerous to the wall-mounted, point-of-sale material Ten's graphics are dynamic and powerful. It also uses graphics in other components like promotional posters [2] and its website [3],

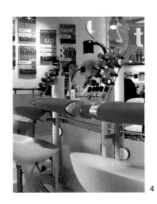

4

to build a strong visual vocabulary for the brand. This visual vocabulary of shape, colour and style is ably partnered by humorous and eye-catching language which does much to build an emotional relationship with consumers – in a way that humour can because it cuts across all barriers.

One of the features which makes Ten interesting is the creative use of the fingernail shape. A prominent part of the brand identity, it also appears in many guises throughout the nail bar and the promotional and display elements. The different stations [4] at the nail bar feature numbered clear acrylic nails while the hand-rest mirrors the shape. The different offers [5], Hand Grenade, Charged Up and Force Ten, continue the theme and the website leaves you in no doubt as to which brand you are dealing with.

3

Client Ten Limited
Design Studio Haggar
Location London, UK
Date 2000

→

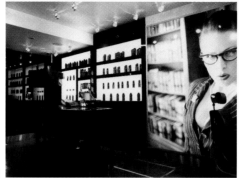

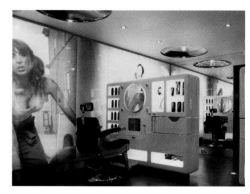

Lynx

Think of a barber shop and if you are of a certain age your mind will probably fill with images of uncomfortable barber chairs and elderly barbers with their armouries of scissors and combs in strange-coloured liquids, and all this surrounded by images of hair styles which were the height of fashion in the Sixties but still have not reappeared as part of any retro fashion craze.

The usual alternative, the unisex salon, where you may be spared the closing comment 'Something for the weekend?', may seem preferable but it still isn't an environment which most men feel comfortable in – let alone young men between 16 and 25.

Lynx was created to change all that. Aimed at fashion-aware young men who are fuelling the rapid growth in demand for male grooming products and services, the new hair salons cater to this market with aplomb. While they wait for their haircut they can play with Playstation 2, or Japanese-import colour Gameboys. Alternatively they can surf the web or read underground magazines from around the

world. While having their haircut they can watch the latest movie or video or catch the latest match from the comfort of their seat.

The whole environment caters to a young man's needs, making the experience more comfortable and enjoyable, and making Lynx a place where they want to hang out. Much of this is achieved through the whole environment but graphics play an integral part in the look and feel of the place.

The two most prominent graphic features (not counting the branding which mirrors the Lynx product brand) combine the old and the new. Each salon features the traditional barbershop pole [1] – said to originate in the days when one visited the barber to be bled for medicinal purposes (hence the red for blood and white for bandages). Juxtaposed with this familiar icon are images which are a million miles away from the norm. Large floor-to-ceiling lightboxes [2] feature photographs of bold, confident women in poses which do much to emphasise their décolletage. These graphics function on several levels. First, they provide a direct link

with the Lynx brand by featuring images from the television advertising campaign 'Grooming to Seduce' – a useful synergy for any brand owner looking to maximise the impact of their brand promotion. Second, they are sure to make a young man's pulse race, and in the process create a more attractive ambiance for young men looking for a comfortable, unintimidating environment. They are also sure to catch a young man's eye from the road as their size determines they are highly visible through the salon's glass frontage, particularly at night.

154

Client Unilever/Elida Fabergé
Design Jump
Location Kingston, UK
Date 2001

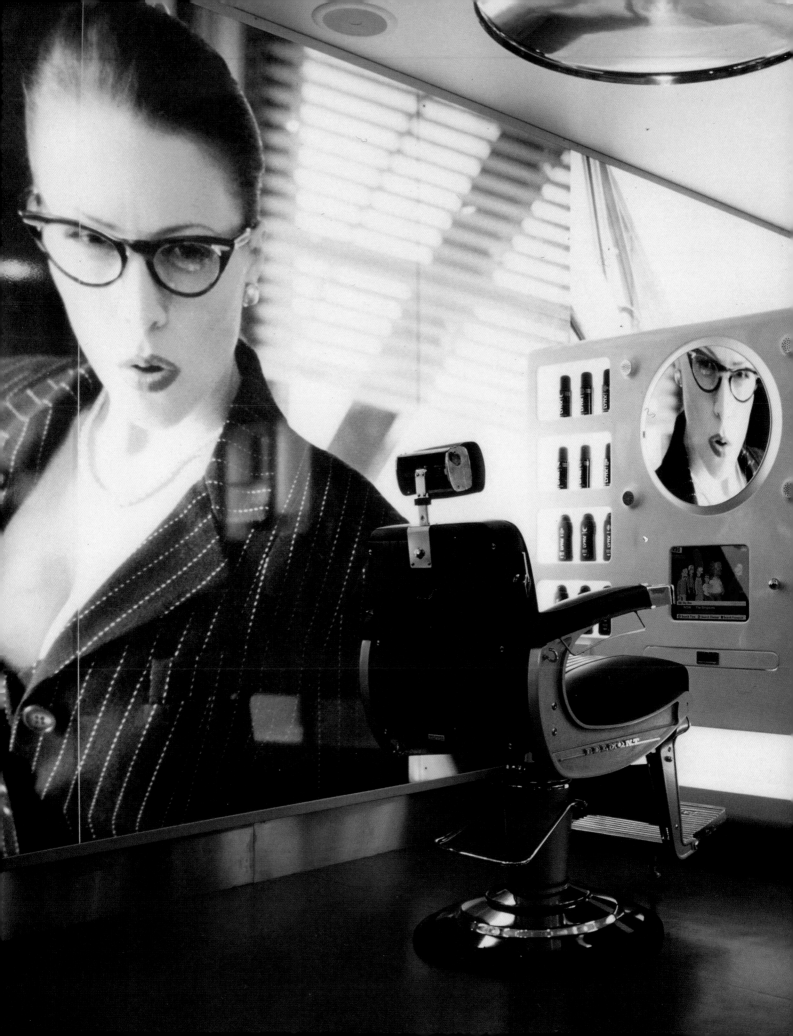

SPECIALITY FOOD

We live in a world where mass production rules: cars, furniture, white goods, electronic equipment and food to name but a few of the products that churn out of factories in large numbers. Even food has now become a factory product – standardised to meet the needs of the 'normal' consumer. Apples which are too small are rejected at the orchard. Tomatoes must be a uniform red…

Despite this, or maybe because of this, there are still people who value provenance, quality, freshness, authenticity, and tradition. Their culture and philosophy dictates their retail approach and influences the tangible and intangible values they espouse. Entering their shops is like entering a different world.

All of the retailers featured share common passions, such as quality, ingredients source and attention to detail, and common communication tasks, such as the 'education' of their consumers. Each does it differently, employing graphic solutions which are involving, aesthetically pleasing and inspiring.

20

Let's Eat

Let's Eat was the first major Australian concept in food and wine retailing, catering for the growing market of time-starved professionals looking for something more exciting than the usual supermarket fare. The Let's Eat emporium offers a selection of fully or partially prepared meals using fresh ingredients, to take away or eat within the store.

Taking over two years to develop and featuring in excess of 1,300 product lines, Let's Eat is at once a fresh food market, florist, bakery, chocolatier, sushi bar, delicatessen, cheesemonger, butcher, greengrocer, classic wine cellar, wine bar, café, snack bar, kitchenware and cookbook shop and cooking school.

One of the things Landini Associates was asked to do as part of their brief was to encourage experimentation by customers and to facilitate interaction with the speciality foods and wines on offer, using technology and innovative signage. As a result educational point-of-sale systems **[1]** offer serving suggestions with each purchase and recommend complimentary wines or deserts. Interactive screens provide information on meals and cooking instructions or print-outs of ingredients.

What is interesting to me about Landini's signage solution is their choice of colour and the simplicity and rigour with which it is used. The black-and-white signage **[2/3]** acts as a wonderful foil to the food with its huge spectrum of colours, and is nicely echoed by the floor and black mosaic tiling on pillars. In turn, the signage is simple and easy to read, combining straight information provision, such as prices and selections, with more engaging and inspiring panels encouraging shoppers to try new combinations or new foods. What's more, someone has thought about the siting of the signage so that it makes shoppers' lives easy. Once you get a handle on where it is consistently hung your eye naturally gravitates to that spot as you navigate the store. It also recognises, like the signage **[4]** behind the wine bar, that there may be times for a more leisurely reading of the information at hand.

And while the signage is doing its job other elements are subtly but collectively communicating the brand: from the frosted window treatment **[5]** to the tear-off recipes, from the caps and aprons worn by the kitchen staff to the name badges worn by everyone. If ever there was a store that made you want to buy a ticket and go visit, Let's Eat is surely one of them.

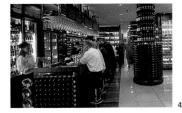

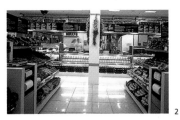

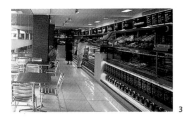

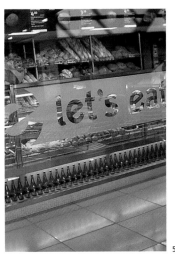

Client Let's Eat
Design Landini Associates
Location Melbourne, Australia
Date 2000

→

A. G. Ferrari

In a world of brands with invented histories and implied pedigrees it's refreshing to find a brand with a true heritage. Since 1948 Ultra Lucca has been bringing the best quality in authentic Italian speciality foods to the San Francisco bar area. Founded in 1919 by Annibale Ferrari, and passed on to family members for generations, the retailer is now run by Ultra Lucca and Paul Ferrari who continue the culinary tradition of catering to the tastes of lovers of authentic Italian food.

The whole retail brand identity, offer and environment is focused on communicating the three values of Italian authenticity, tradition and quality, and providing a distinctive identity for the stores, not only in the San Francisco area but nationally.

From the exterior treatment of the stores [1], with their bright attention-grabbing and partisan signage, through to the interior signage [2], packaging [3], customer literature and fresh produce bags the three values are promoted through a compound of elements. The logotype features a detailed pictorial etching that captures and expresses the company's distinguished heritage. The packaging uses rich material such as craft paper, Old-World-style typography and fresco-inspired illustrations. The take-out bags [4] feature the Italian names for the produce – a little bit of Italy in your hand.

The chalk board signage, handwritten pricing and food facts, such as the olive variety identifiers, all testify to the passion, attention to detail and authenticity of the offer. The menu cards [5], with their deck-led edging, debossed logo and tactile paper stock speak of an era before mass production, and of quality. For those people who have more time to linger there is a large display panel [6] introducing the company, its history and its origins.

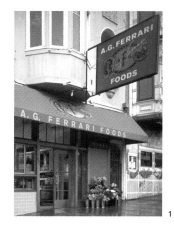

1

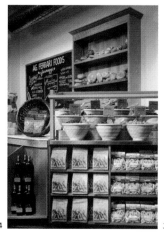

5

3

4

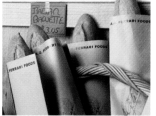

2

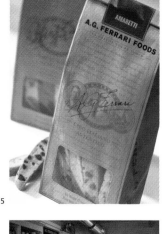

6

158

Retail Graphics
Speciality Foods

Client A. G. Ferrari
Design Landor Associates
Location San Francisco, USA
Date 2000

DESIGN DIRECTORY

Allen International
7–13 Berghem Mews, Blythe Road,
London, W14 0HN UK
Tel: 020 7371 2447
www.allen-international.com

Ben Kelly Design
10 Stoney Street, London, SE1 9AD UK
Tel: 020 7378 8116

Body Shop International plc.
Watersmead, Littlehampton, West Sussex,
BN17 6LS UK
Tel: 01903 731500
www.the-body-shop.com

Carte Blanche
4–5 Fitzroy Mews, London, W1T 6DG UK
Tel 0207 387 1333
www.carteblanche.co.uk

Checkland Kindleysides
Charnwood Edge, Cossington, Leicester.
LE7 4UZ UK
Tel: 0116 264 4700
www.checkind.com

Chermayeff & Geismar
15 East 26th Street, New York,
NY10010 USA
Tel: 1 212 532 4499
www.cgnyc.com

Cobalt Consultancy Ltd.
9 Tufton Street, London, SW1P 3QB UK
Tel: 020 7222 2882
www.cobalt.co.uk

Crabtree Hall Projects Ltd.
1 Grimston Road, London, SW6 3QT UK
Tel: 020 7381 8755
www.crabtreehall.com

Creative Action
Hanover House, 3 Holywell Hill, St Albans,
Hertfordshire, AL1 1ER UK
Tel: 01727 799999
www.creativeaction.co.uk

Design House Consultants Ltd.
120 Parkway, Camden Town, London.
NW1 7AN UK
Tel: 020 7482 2815
www.designhouse.co.uk

Din Associates
32 St Oswald's Place, Vauxhall, London,
SE11 5JE UK
Tel: 020 7582 0777

Egan Melia
32–34 Great Marlborough Street, London,
W1V 1HA UK
Tel: 020 7439 0199
www.eganmelia.co.uk

Emery Vincent
Level 1, 15 Foster Street, Surrey Hills,
NSW 2010 Sydney, Australia
Tel: 61 2 9280 4233
www.evd.com.au

Fernando Amat
Vinçon
Passeig de Gracia, 96
08008 Barcelona, Spain
Tel: (34) 93 215 6050
Fax: (34) 93 215 5037
bcn@vincon.com

Fern Green Partnership
20 Shepherdess Walk, London, N1 7LB UK
Tel: 02 0 7490 7911
www.ferngreen.com

Fitch Design Consultants Ltd.
2nd Floor, 10 Lindsey Street, Smithfield
Market, London, EC1A 9ZZ UK
Tel: 020 7509 5000
www.fitch.com

FRCH Design Worldwide
311 Elm Street, Suite 600,
Cincinnati, Ohio USA
Tel: 1 513 362 3333
www.frch.com

Gensler
One Rockefeller Plaza, Suite 500, New York,
NY 10020 USA
Tel: 1 212 3492 1400
www.gensler.com

Holmes & Marchant Graphics Ltd.
Marlow Place, Station Road, Marlow,
SL7 1NB UK
Tel: 01628 890890
www.holmes-marchant.com

Imaginif nv/sa
Chaussée de Waterloo 440, B-1050
Brussels, Belgium
Tel: 32 2 537 5114
www.imaginif.com

Interbrand
85 The Strand, London, WC2R 0DW UK
Tel: 0207 554 1000
www.interbrand.co.uk

John Lewis Partnership
171 Victoria Street, London,
SW1 E5NN UK
Tel: O20 7828 1000
www.johnlewis.co.uk

Jon Greenberg & Associates
29355 Northwestern Hwy, Suite 300,
Southfield, Michigan 48034 USA
Tel: 1 248 355 0890
www.jga.com

Journey
Crown Reach, 147a Grosvenor Road,
London, SW1V 3JY UK
Tel: 020 7834 0534
www.thejourney.co.uk

Jump
35 Britannia Row, London, N1 8QH UK
Tel: 020 7688 0080

Landini Associates
Level 12, 54 Miller Street, North Sydney,
NSW 2060, Australia
Tel: 02 9929 6922
www.landini.com.au

Landor Associates
Klamath House, 18 Clerkenwell Green,
London, EC1R 0DP UK
Tel: 020 7880 8482
www.landor.com

Lippa Pearce
358a Richmond Road, Twickenham,
Middlesex, TW1 2DU UK
Tel: 020 8744 2100
www.lippapearce.com

Lewis Moberly
33 Gresse Street, London, W1P 2LP UK
Tel: 020 7580 9252
www.lewismoberly.com

Lumsden Design Partnership
1 Hanover Yard, Noel Road, N1 8YA UK
Tel: 020 7288 4290
www. ldp.co.uk

Martin Jacobs Design
23–25 Great Sutton Street, London,
EC1V 0DN UK
Tel: 020 7608 1968
www.martinjacobs.com

Michael Nash Associates
42–44 Newman Street, London,
W1P 3PA UK
Tel: 020 7631 3370

Mother
200 St John Street, London, EC1V 4RN UK
Tel: 020 7689 9629

Noble Associates
123 Cleveland Street, London W1T 6QA UK
Tel: 020 7631 1161
www.noble-assoc.com

North
Unit G2, The Glasshouse, 156–170
Bermondsey Street, London, SE1 3TQ UK
Tel: 0207 357 0071

The Partners
Albion Courtyard, Greenhills Rents,
Smith Fields, London, EC1M 6PQ UK
Tel: 020 7608 0051
www.partnersdesign.co.uk

Pentagram
11 Needham Road, London, W11 2RP UK
Tel: 020 7229 3477
www.pentagram.com

Pentagram Design Inc.
204 5th Avenue, New York,
NY 10010-2101 USA
Tel: 1 212 683 7000
www.pentagram.com

Rodney Fitch
Northumberland House, 155 Great Portland
Street, London, W1 W6QP UK
Tel: 020 7580 1331
www.rodneyfitch.com

Rawls & Co.
133 The Strand, London, WC2R 1HG UK
Tel: 020 7203 4567
www.echochamber.com

Red or Dead
Pentland Group, Pentland Centre, Lakeside,
Squires Lane, Finchley, London, N3 2QL UK
Tel: 020 8346 2600
www.pentland.com

Research Studios
Unit 2, Whitehorse Yard, 78 Liverpool Road
Islington, London, N1 0QD UK
Tel: 020 7704 2445
www.researchstudios.com

RPA
580 North 4th Street, Columbus,
Ohio 43215 USA
Tel: 1 614 564 1020
www.rpaworldwide.com

Rodney Fitch & Co.
Northumberland House, 155 Great Portland
Street, London, W1W 6QP UK
Tel: 020 7580 1331
www.rodneyfitch.com

SCG London
Unit 8, Plato Place, 72–74 St Dionis Road,
London, SW6 4TU UK
Tel: 020 7371 7522
www.scglondon.uk.com

Selbert Perkins
1916 Main Street, Santa Monica,
CA 90405 USA
Tel: 301 664 9100
www.selbertperkins.com

Selfridges & Co.
400 Oxford Street, London, W1A 1AB UK
Tel: 020 7629 1234
www.selfridges.co.uk

Spacecraft
18 Trafalgar Avenue, London, SE15 6NR UK
Tel: 020 7277 0054

Start Design Ltd.
Kingsbourne House, 229–231 High Holborn,
London, WC1V 7DA UK
Tel: 020 7269 0101
www.startdesign.com

Studio Hagger
68 Thames Road, Chiswick, London,
W4 3RE UK
Tel: 020 8747 3000
www.studiohagger.co.uk

Studio Myerscough
28–29 Great Sutton Street, London,
EC1V 0DS UK
Tel: 0207 689 0808

Tango Design
Newcombe House, 45 Notting Hill Gate,
London, W11 3LQ UK
Tel: 020 7569 5757
www.tangodesign.com

Taylor Mckenzie
58 Charlotte Road, London, EC2A 3QG UK
Tel: 020 613 3130
www.taylor-mckenzie.co.uk

20/20 Limited
20–23 Mandela Street, London,
NW1 0DU UK
Tel: 020 7383 7071

Virgile and Stone Associates Ltd.
25 Store Street, South Crescent, London,
WC1E 7BL UK
Tel: 020 7323 3300
www.virgileandstone.com

Ytterborn & Fuentes
Norrlandsgatan 18, 111 43 Stockholm,
Sweden
Tel: 46 8 54 50 66 00
www.ytterborn-fuentes.com

Williams Murray Hamm
The Heals Building, Alfred Mews,
London, W1P 9LB UK
Tel: 020 7255 3232
www.creatingdifference.com

INDEX

ACKNOWLEDGEMENTS

I'd like to thank all of the retailers featured for giving us permission to include them, and all of the designers for the time and effort they have devoted to providing images and information relating to their projects. I'd also like to thank the photographers whose images are featured, in particular:

Morley von Sternberg: View on Oxford Street, pages 18–19

John Critchley: John Lewis Partnership, page 28.

Richard Foster: Audley Shoes, pages 96, 97, 98 & 99, Soup Opera, page 116 [2], Halfords Limited, page 123 [1/3/4/6/7].

Richard Glover: Halfords Limited, page 23, 34, 122 & 123 [5] and Dr Martens, page 31.

Bielenberg Associates (Paul Bielenberg): Macy's Home Store, pages 130 & 131.

Ian Lambott: ATT, page 20.

Richard Learoyd: Lund Olsen, page 139 [2/3/4].

Ake E.son Lindman: McDonald's, page 113.

Jon O'Brien: Next, page 12, and Soup Opera, page 117.

Abigail Silvestre: Sale windows, page 79.

Peter Paige: Discovery Channel, page 47 and Velvet Pixies, page 144 & 145.

Harry Pearce: Halfords Limited, page 121 & 123 [8].

John Ross: Waterstone's, pages 84 & 85.

View Pictures: Lund Osler, page 139 [1].